SALAD DAYS IN SUTTON

~~~

## Charles W. Sanderson

~~~

Scarthin Books, Cromford, Derbyshire
1985

A

i

ACKNOWLEDGEMENTS

*I owe grateful thanks to the proprietors of CHAD, the Mansfield
Chronicle and Advertiser, and to the editors, Jeremy Plews and Alfred
Jackson: to Kevin O'Hara and the staff of Sutton Library: to Mrs. Edith
Bolton of Mansfield for the loan of the photograph of the brake: and to
W. H. Pickard for the school photograph.*

Published 1985 by Scarthin Books, Cromford, Derbyshire.

Phototypesetting, Printing by Higham Press Ltd., Shirland, Derbyshire.

ISBN 0 907758 14 2

Contents

		Page
Intro:	Eighty years ago.	1
1.	In and Around Sutton.	3
2.	Characters.	12
3.	Schooldays and games.	17
4.	Holidays & Whit Walks.	25
5.	Christmas.	30
6.	The Penny Emma.	34
7.	Gospellers.	38
8.	Brake Ride.	41
9.	Sutton Wakes.	45
10.	Cricket.	51
11.	The Monkey Run.	57
12.	Courting.	61

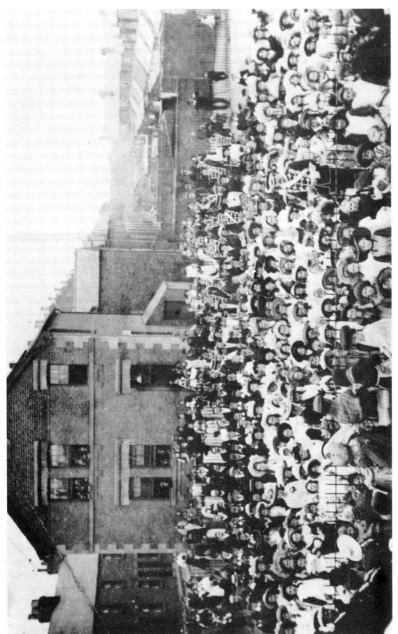

Gathering for Whit Walks.

INTRODUCTION
Eighty years ago

I was born late in December 1906, in Sutton-in-Ashfield, a small Nottinghamshire town of some fifteen or twenty thousand souls.

I fear that I came to my parents as a rather unwelcome Christmas present, having had two predecessors, and as my father had been without work for six months my arrival coincided with a difficult time. There were two more to follow, but sadly one died at about two months (a little girl). The boy whom she followed thrived, and is alive and well in this year, 1985. I never remember my mother being really sound in health, and I well recall that wan little baby,—the result of mother's poor condition—though I was only a small boy myself.

I relate the foregoing to illustrate that, like the rest of the town with few exceptions, we were poor, though I must say we were much luckier than many other children, being blessed with splendid parents who always kept us clean, well-fed, clothed and shod, I'm sure at great sacrifice to themselves.

Edward VII sat on the throne of England, but Victorianism never really died until the outbreak of the 1914 War. The style of dress never seemed to have altered. Women still wore dresses down to their ankles. They had heads, bodies and feet,—legs were immodest. I have seen many homes during my childhood with table legs encased in footless cashmere stockings, ostensibly to protect them from the flying feet of unruly little boys; but the wags all asserted that the ladies thought it indecent to expose even table legs to the blatant stare of the lecherous male.

The men, well, they were never the slaves of fashion! Stiff linen collars (sometimes rubber ones, faced white) severely cut jackets, narrow trousers, always a waistcoat with the luckier ones sporting a watchchain, suspended from pocket to pocket, perhaps bearing a talisman of some sort which was lovingly fondled by adoring fingers. It made them feel important, but it also made them look pompous.

This was still the age of the dominant male. The father ruled his household with a rod of iron, though some women henpecked their men, reducing them to pitiful objects of derision, targets of all and sundry. The sartorial description, of course, applies mainly to Sundays, when there was much Church-and-Chapel-going, for on weekdays a neckerchief was more in evidence than a collar and tie.

Babies of both sexes were wrapped in swaddling clothes, the underlayer often of red flannel "to keep 'em waarm" no matter what the

1

season. The ensemble was completed with a very long nightie, mostly twice the length of the child. Grown-ups had tremendous faith in red flannel, though I fail to see any thermal difference between red, white or any other colour! Nevertheless, this miraculous fabric was applied to all sore chests and aching backs, regardless of age.

There were no fancy baby foods in those days, and if there had been most mothers could not have afforded them. Consequently almost all babies were suckled at the mother's breast, in full view of the rest of their brood. This was such a common practice that no one took the slightest bit of notice, least of all the mother, who could not but let the loveliest smile escape her lips, and adoration shine from her eyes, in this sweet intimacy.

When the little ones graduated from their wrappings they were dressed much like their elders; the girls in longish frocks; and underneath drawers with frilled bottoms which reached down to their knees; and woollen stockings held aloft by garters to cover every possible inch of bare flesh, in order not to corrupt the wide-eyed gaze of little boys.

The boys were likewise garbed in the style of the fathers, except that instead of trousers they wore shorts, or knickerbockers,—cumbersome garments buttoned at the knee. Boys rarely reached the dignity of "long-uns" before they left school at thirteen.

How to end a quarrel

Quarrels were non-existent. Father saw to that so far as we were concerned. I do not ever remember a quarrel between my parents in our presence, the worst you could ever hear from my mother was "Fart on thee Jonah," if he was a little out of humour.

In and Around Sutton

Sutton was fringed on one side by rolling sandy hills known as the moor, and though the wind could whistle around one's ears in winter time, it was quite unlike the bleak and barren moors of Derbyshire. Indeed, it was well-wooded, and in parts, gorse grew in profusion. It was quite a sight in the early summer when it bore its yellow flowers!

Rising grassland was grazed by cattle and sheep, interspersed with good arable land which produced grain, mangolds and swedes. It was carved up by hedgerows and intersected by undulating, dusty metalled roads, which knew no traffic but the feet of men and the clopping hooves of horses drawing carts and wagons.

Some gradients were such that the driver would leave his seat to urge his horse along by the bridle. There were also a few sand quarries as the whole area lay on a bed of sand, though it was mostly covered with a rich assortment of wild flowers and threaded with lovely country lanes. This was a truly rural scene.

Men and milkmaids could still be seen carrying pails with the ancient wooden yoke, the like of which had served their ancestors for centuries. We children knew every farm, every field and path and roamed the moor at will, especially during summer school holidays.

Then, our mothers would pack us a few very thick slices of bread and jam (wedgers we called them), and would provide us with a bottle of water with string tied round the neck to sling over our shoulders, and they would send us off for the day to be home for teatime. We would often see a tramp, (there were many in those days), lying fast asleep in some hedgebottom warmed by the summer sun. But if he were afoot we had no fear, children could walk about unmolested then. If we ran out of 'wedgers' and fancied a 'doney' (turnip) we would freely help ourselves from the fields. Kids used to walk so many miles that they always seemed to be hungry.

The other side of town was much lower so we had a High Street and a Low Street, the terrain falling fairly sharply and the market square lying betwixt the two. The market place itself was rather steep from bottom to top. The older part of the town was the very heart of the place, with nearly every cottage built in stone. There were narrow streets, some crooked, all short, and interconnected with what could only be described as alleyways. Many of the cottages were roofed with red pantiles, mellowed with age. The window frames embraced a goodly number of small square panes, some of bottle glass. Doorways were often so low that a tallish man

would find it necessary to lower his head and bend his shoulders in order to gain entrance.

Though the interiors were far from palatial, they were kept spick and span, by rubbing, scrubbing housewives. The centre piece of the living room was a deal-topped table, which was bleached to a dazzling whiteness by constant washing and scouring. The focal point of the whole lot was of course, a great roaring fire which filled all the chimney throat. This cheerful glow was surrounded by a fireplace, with an oven on the one side and a boiler for hot water on the other.

All this was presided over by a mantel shelf, adorned with a skirt of crocheted lace with dangling 'Gin Jogs', (these were glass stoppers from lemonade bottles), the shelf bearing various ornaments often flanked by a pair of aristocratic-looking pot dogs.

The fire was never allowed to die out in wintertime, as coal was cheap and plentiful, (not so cheap as the lives of the men and boys who burrowed in the bowels of the earth to mine it, sad to say). The whole cooking range was black-leaded, and hinges and knobs of oven doors burnished with such zeal, that one could see the reflection of every object in the room. To achieve this glittering result the houseproud lady would sagely inform its beholders "Its 'ad plenty of elbow grease."

I have said they were not palatial dwellings, but in the eyes of those who dwelt therein, they were indeed little palaces, and some would boast their floors were so clean, "You could eat your dinner off 'em."

The shops were mainly concentrated in the area of the market place and the low street, but every other street had its corner shop and often one in the middle or even more. Napoleon was not very far from the truth when he alluded to us as a nation of shopkeepers—they seemed to be everywhere.

The market was held each Saturday, and the market place would almost overflow with a jostling mass of men, women, kids, cats and dogs, the latter waiting for offal, discarded bones and fish tails, thrown down by the vendors.

Strangely enough, the market seemed a more cosy place during the short winter days, as when daylight faded, the stalls were illuminated by paraffin lamps. These lamps were very curious contraptions, consisting of a vessel like an inverted cone with a priming pump at the top, with a pipe at the lower end extending vertically but curled up at its extremity, bearing the burner. They were made of brass and were suspended by a hook from the ridge of the stall roofing. These lamps issued a guttering flame, and swung to and fro when there was wind but were seldom blown

out. The miracle was, that the stallholder didn't get his whiskers singed and the whole place afire on windy days. There was a quaint old fashioned romanticism about this form of lighting, very different from the brash, soulless stare of electric lighting.

What streets were lit, were of course furnished with gas lamps. The street where I lived never boasted a light during the years I spent there, and was indeed never made up, and remained a quagmire of mud in the winter and a dustbowl in summer. Each evening at dusk, the lamplighter did his round, bearing on his shoulder his long brass pole terminating with a candle which was protected by a cowl. He returned at daybreak to reverse the process.

Many who visited the market did not do so to spend money, especially the children. We went to see the free entertainment. The adults, after completing their shopping, joined the gaping audience. Here was the artful quack, the self-styled Dr. Collard, who while delivering his persuasive patter, held aloft a jar of spirits containing corns, bunions, ingowing toe-nails and pebbles. These pebbles were reputed to be gall stones, some almost as big as eggs, extant from suffering humanity who were aided in their rejection by his wonderful pills and potions.

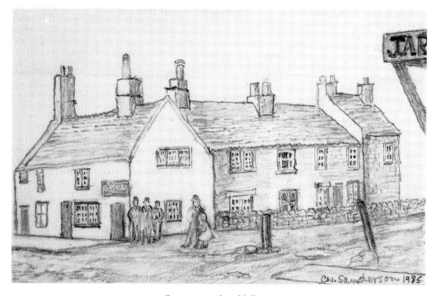

Cottages on the old Green.

5

All were assured that without his healing balm they would suffer an early demise. For diversion, if interest palled, he would seize a great sword and wield it with two hands between two adjacent wired points, which were so positioned as to produce a brilliant white arc of light when the steel blade passed between them. Thus he attempted to blind his prospective patients into submission. Where he got his current from I cannot say, but he must have had a generator of a sort hidden from view, driven by I know not what, as there was no general electricity supply in those days. This worthy always dressed in a top hat and frock coat, and a toothbrush 'tache adorned his lower lip. He was indeed quite an arresting figure and had little trouble selling wares to the more gullible.

We were sometimes favoured with a Punch and Judy show and also regaled in song by some merry tippler issuing from one of the pubs. The place was littered with pubs.

On top of all this, we had real music to drown the bedlam of voices. This was always at the top corner of the market place and was provided by the Salvation Army band in their indefatigable quest for converts. They formed themselves in a circle to play hymns. The conductor stood in the middle to keep an eye on all his instrumentalists, and gyrated one way and another and so almost performed a dance. The girls and ladies shook their tambourines to the rhythm and sang so lustily that I used to feel that they were already halfway to heaven.

Between musical items, one of their number would try to deliver some Christian message to the people gathered around, being quite undeterred if their words fell upon stony ground. It was also customary to introduce the latest converts to tell the assembled company how their souls had been saved. Unfortunately, the Salvation Army seemed to attract vagrants and people of rather low mentality, like a magnet—those who would do anything for a little attention.

Of this number, a local known by the name of Nicodemus (no-one knew his real name) one night took his stance in the circle and in his garbled fashion proceeded to relate his former misdeeds and told of his subsequent reformation, to the accompanying chuckles of the bystanders. He pranced and gesticulated in an effort to get his message over and worked himself into such a lather of excitement that in a moment of forgetfulness, he bellowed: "I feel so full of salvation tonight, I could bost (burst) the bloody drum."

The chuckles burst into a mighty roar of mirth and everyone went home happy and well pleased, save perhaps the bandmaster.

This then was the end of a week of labour and the prelude to a sober Sunday.

6

Apart from the parish church and the largest chapel in the town (we had them all, Baptist, Methodists etc.) there were few notable buildings. The church of course, was, and is a fine old edifice. The larger chapel is a wonderful example of perfect brickwork. This was pointed out to me by one of the leading builders of the town.

The only other building really worthy of mention is the so-called Town Hall, not because of its architectural beauty but because of its rather unusual beginnings. As related to me, this is the story: A consortium of businessmen and would-be opportunists, with what I hope was a sense of civic pride, decided that the time was ripe for the dignity of a town hall. Whether they were local men or not, I do not know, but whoever they were they must have put the project into operation without the official agreement of the council.

The building was duly completed with a reasonably impressive foyer and ballustraded stone staircase, leading to a large hall presumably intended for a council chamber. The whole erection was supported by shops to be let, and then topped by a smallish clock tower. Unfortunately, before the actual clock could be installed, the council didn't want to know, so the wily promoters cut their losses and the clock was never put in its appointed place. It was a standing joke for many years that if one asked the time of someone else, someone who had no timepiece, you would be advised to consult the town hall clock.

In the reigns of Edward VII and George V one could stand on Sutton Market Place and take exit from it, and on one's own two feet could reach open fields and the countryside within 10 minutes. Stand up all those over 60 and bear witness!

If we ignored High Street at the top left corner of the market place, which led to a veritable labyrinth of narrow streets and old property, and instead took the more direct route of Victoria Street, then crossed High Pavement to Crown Street, it was but a step to the Twichell and the 'Broady.' From the Broady wound the Old Lane right through to Kirkby—a narrow country lane bordered by tall, thick hedges which absorbed the chatter of children and so created an atmosphere of peace and silence like that of a forest glade. Of all the wild flowers that grew there two are impressed upon my memory—Cuckoo Pint or Lady's Mantle (we called it red hot poker), and the wild orchid with the blotched leaves.

Back at our starting point we could walk along King Street to Spring Bank and up Kirkby Road on the one side and Brigg's hosiery factory on the other. Between there and Kirkby Cross there was nothing but farmland, and Kirkby Road itself though metalled, was but a little wider

7

version of the Old Lane, the main difference being that Kirkby Road did echo with the ring of horseshoes and the rumble of cartwheels: indeed, we used to refer to Kirkby Road as Kirkby Lane.

From the meadows between the two lanes which I have tried to describe came the moo of a cow and the neigh of a horse. Immediately before Kirkby Cross a lane ran to the right which led to Dumbles Wood and later by pathway through some meadows, forming part of the 'Weeds', eventually emerging close to St. Mark's mission on Alfreton Road.

The Dumbles Wood was very small and the site unusual in that it was quite out of character with the surrounding area. Mature trees grew in a very deep gully or cleft—it could have even be described as a miniature ravine. It was long in comparison to its width, and its steep sides and rim were clothed with trees. The tops of those growing at the bottom appeared to be at one's toes when viewed from the rim. It was a fascinating little wood, a children's paradise where they could scramble up the sides and their excited voices echoed through this cloister of nature. Many a pseudo Tom Mix ran to earth a wretched Redskin hiding amongst those trees.

Leaving the market by way of Brook Street and turning left at West End, a few yards walk would bring into view Spring Bank. Just before the ascent of Kirkby Road, a leafy narrow path turned off to the right and we were now again away from the steets. Along this path, sheltered by a tall hedge, ran a little brook which I believe was diverted and at some point piped under the road to Brook Street and the Idlewells. Whether this stream was the Idle itself or a tributary I cannot say.

In the space of a minute we were on the Weeds, a succession of meadows grazed by cattle who might greet you with a lazy moo. These meadows extended as far as Alfreton Road and at a point where the land began to rise was a field I will never forget. Moisture, drained from the slope, was concentrated in a shallow muddy pool held there by a retaining hedge. This may have made conditions right for a sight of something rarely seen today. On this meadow grew a host of primroses and cowslips every springtime. Could anything be more rural than a herd of lowing cattle grazing on a carpet of gold?

From the other bottom corner of the Market Place we could choose either Market Street or Low Street to make our way across Manor Square, and from there take the entrance (we called it a jitty) between the Old Blue Bell and the Free Press Works. At the end of the jitty were Wass's fields with the path leading to Stoneyford Road—here again was water in the hedge bottom but I cannot recall whether or not it was a

moving stream. On reaching Stoneyford Road, one had but to cross it and there was Quarry Dale at the entrance to Skegby Bottoms, the latter a delightful little walk to Skegby Hall. Then across Mansfield Road, Skegby, up the church path and right through to Teversal churchyard, following paths that had nothing wider than a country lane to cross, all the way to Hardwick Park in Derbyshire.

We had just one more exit to explore—that crooked, twisting maze of narrow little streets beginning with High Street which led us to Parliament Street, Mount Street, Station Street and Hardwick Lane, the end of which marked the end of Sutton in that direction. We were now again at the 'Broady,' and also the gateway to the showpiece of the area—Coxmoor.

First we crossed the bridge over the Great Central Railway cutting, made when I was a boy—and I remember very clearly many occasions when we children watched this scene of unusual activity. We had our first sight of the great 'American Digger' with its mighty gib and steel-pronged bucket which bit into the soft earth and scooped up at one bite enough to fill a cart.

As the cutting got deeper there was the excitement of the shot blasting of the stubborn rock, and at a given danger signal, all withdrew to a safe distance to listen for the bang: then after the dust had settled and the all-clear had been signalled, all would return to watch the digger gobble up the rock and rubble and drop it into waiting wagons. The whole scene was peopled by tough Irish navvies moving about like busy ants. These navvies were a thirsty, rough, rollicking lot who made their presence felt in the local pubs, but they often met their match amongst the local roughnecks whose tempers were no less abrasive, when in their cups.

From this point we crossed the Northern railway line and followed the path through the fields of Kirkby Hardwick, then walked beside the 'Tittle Brook' (we often paused there for a little paddle), and after climbing one of the many stiles of the area, crossed the Midland line to Nottingham which brought us to our last obstacle, Lowmoor Road, the threshold to Coxmoor.

Coxmoor, that large expanse of undulating, sandy hills was not then as it is today. To our left lay Tommy Hardwick's farm sheltering in a dip between two hummocks and therefore not visible from this point. Before our eyes, stretched an uninterrupted view with not a solitary building in sight until we reached the road that crossed the top that led to Derby Road.

9

Here stood two lonely houses and the Coxmoor Golf House, and hidden in a cleft the tiny Fever Hospital. The moor was grazed by quite a number of sheep and was the home of countless rabbits which provided sport and dinners for the local poachers. It was also a secluded fighting ground on occasional Sunday mornings for now-sobered gladiators, who met to settle their drunken differences of the night before, watched by a ring of men there to see a fair fight.

From the top of the moor amid a profusion of golden gorse, we could look down on Sutton and pinpoint its salient features—the Croft school tower, various factory chimneys, the Congregational Church tower and steeple, and piercing the sky the belfry and slender spire of the mother church, St Mary's. She looked down on ancient stones that marked the resting place of her sons and daughters who had found solace and comfort within her walls.

With this sober thought in mind, if we turned to continue our way and allowed these thoughts to linger, half an hour brought us to a sombre spot, which though pretty in itself would do little to lift our mood. Cauldwell Dam, the 'Stockinger's Rest,' so called because many a distraught soul broke the still surface of that water and came out a corpse. It is in a sheltered place and was well away from any habitation, a quiet place where these perplexed and tortured mortals could pass to eternity with the minimum of indignity.

Two such tragedies I well remember—one a girl of 21 who misappropriated a few paltry pounds which could have been replaced and the incident forgotten in a week. A heavy conscience would not allow her to face her people and friends, so she took her life in a fit of remorse. I knew the girl right from a child. She paid dearly for a petty lapse which resulted from a foolish impulse. It was very sad.

The other case concerned a couple—she belonged to another—victims of their own eternal triangle. He was a seaman who would perhaps instinctively struggle to survive, but so intent were they in their purpose that their bodies were found tied together. With whatever virtues we may flatter ourselves, not one of us can be the judge of such pathetic happenings. We should instead tender our sympathies.

Let us forget the dam and recall the pleasant things. Think of Cauldwell Wood and the annual trek to search for chestnuts, pillowslips full of them. Scent again the autumn fragrance of that quiet wood where but a whisper or the fall of a single leaf could be heard amongst those silent trees. That wood was later to hear the ring of the axe of the lumberjack, and the rasp of his saw. Those majestic trees were to crash to

lie prostrate as if bemoaning the destruction of a century's work of nature.

That was to give rise to another scent—the aroma of fresh-cut green wood, found only in such places or in the seasoning shed of a timber yard. It was exciting for us children to watch those Canadian woodmen chip away at a mighty trunk in perfect rhythm, then double on a crosscut saw to cause the tree to fall on a pre-determined spot. The trimmed logs were then drawn away on lumber carriages by a team of powerful horses.

This massacre left a sorry sight. What had been a great mound of green was now a forest of pathetic stumps showing their naked wounds amid a carpet of chippings and sawdust. I do not remember any re-planting being done, but after a period of almost 70 years the wood is somewhat recovered—I would think largely due to the tillering of the remaining stumps and the growth of seedlings.

The 'Stockinger's Rest' today appears unchanged, now that a new generation of trees give her shelter—trees that help her to guard the secrets of those who sought oblivion in her chilly waters.

We climbed the hill, then down again to the crossroad where stood the 'White House', and were now within the sight of the Junction level crossing and the first cluster of buildings of the town—a few cottages and the Cart and Horse Inn. If we really hurried we could achieve our target and be back on the Market Place and so preserve our 10-minute claim.

If you do not believe what I say—ask the 'Old Ones.'

The Nightingale

I recall a summer of the early 1920s when it was reported that a nightingale was giving a regular performance in the Dumbles. People went there in droves to wait all night in the hope of hearing its song. Some said that they did, which I do not question, but when a friend and myself went, we found the wood full of people—some even with picnic stoves and sandwiches. The hum of conversation was sufficient to drown the voices of half a dozen nightingales and no self-respecting bird could be expected to stand for that.

Characters

The couplet of a certain nickname and a surname that belongs to it seem to me, just right and nothing else will ring true.

The people I am thinking of brought sunshine and laughter to many a drab moment and never did anybody any harm whatsoever. These same born humorists, brought up children who grew to be as good and respectable as any that ever walked. They were just naturally funny people, often without knowing it.

These worthies had diverse nicknames some not exactly of a flattering nature, but did they care? Not on your life. Indeed, in most cases, they were rather proud of them and it is doubtful if they would have answered to their proper names if addressed by them. I myself still do not know them, but I remember very clearly, those who bore them. Some of the names were quite outlandish.

We had, "Mucker Smith," "Farter Skerrit," "Fatty Chadburn," "Snifter Barrows", "Tipper Butler," and others, all good men and true.

Some occupied a special niche of fame but as the fair sex should always take precedence, there is one lady who stands out above all her sisters in the immortality stakes. This was, "Cocky Louisa." She was known all over the town.

Her special function was the laying out of corpses of those who for various reasons were deposited in the local mortuary. One of the charges, a journeyman painter only temporarily in the town, achieved notoriety by murdering a girl he was keeping company with. This of course created a sensation and became the topic on the lips of everybody and was even more sensational as he dodged justice by eliminating himself at the same time.

When the formidable "Cocky Louisa" was questioned by her inquisitive cronies as to what this fellow was like she replied "Well, I looked at him an'thowt, your' a bad un if eer ther wor' one, so I tonned 'im oer an' slapped 'is arse." She received the credit of a least meting out a little justice apart from causing some ghoulish amusement.

Old Tommy Farrands the postman, was a small grey-haired man who trod his round of the streets with a kind of uneven, faltering step; always head down, eyes on the ground, yet never seemed to pass a door where he had to deliver his mail.

Delivery was accomplished with a sideways thrust at the letter box (if the door boasted one, otherwise the mail went under the door). Through long practice he could do this without ever averting his eyes. His gaze

would be fixed on a postcard, intently reading whatever message it bore. By this means he was the possessor of much advance information. By mere instinct, he thus continued on his way and would arrive safely back at the post office, with an empty bag and his duty done.

He was so familiar with his beat that it was of no consequence whether his feet knew what his head was doing. He always seemed to me to be an inoffensive old man in spite of his curiosity. One day he walked and didn't stop, disappearing into the mists of time.

Some achieve distinction in middle age; some labour a lifetime to gain their halo, others never make their mark, but the favoured fortunate ones have it thrust upon them in the tender years, not always of their own seeking.

"Dotty (dirty) legs Miller," was of the latter group. The occasion was the annual visit of the menagerie, a great day for all the youngsters of the town. Young Miller from a vantage point before the lion cage, surveyed its occupant with a wondering stare. The king of the jungle espied this plump and tasty morsel and somehow broke away from his cage. The tale was as told to me by my father, who did not supply any details as to how this happened so one must accept the story as it stands.

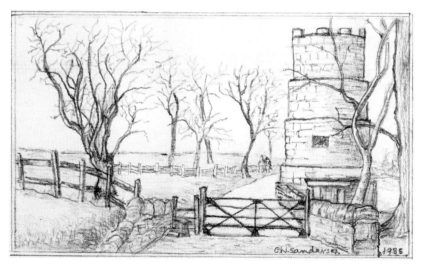

The old tower on the Mill Dam by the Lawn Pleasure Grounds.

On the lion's roaring exit, off went our juvenile hero as fast as his legs could carry him. What happened to the lion I was not told, but when Miller junior was eventually located his black-stockinged legs had assumed a distinct shade of brown. This change of colouring could not be sunburn as his legs had now a double covering. Such is the price of fame and the acquisition of a unique nickname,—it stuck to him for the rest of this days—I mean the name, but could he care? Certainly not!

He grew up to be a jolly red-faced man, fat and round, had a spouse of ample proportions and raised a brood of bonny red-faced kids with cheeks as rosy as the apples he sold from his stall on the market. Everybody knew him, liked him, and any reference to this youthful adventure always raised a smile.

A gentleman, usually attired in top hat and black frock coat, was regularly to be seen taking the air in the streets. At the time I remember him he would be retired, as he always seemed to be about. He was a tallish gentleman who took rather long strides and had an air of inquisitiveness about him. His most salient feature was his nose, remarkable in more senses than one. This nose was highly coloured, large, pimply and bulbous. It was a veritable beacon.

Ambrosia being the fabled food of the Gods, and our worthy being heaven sent, was christened with the succulent name of Ambrose. Of an inquiring turn of mind, he acquired the reputation of being "Nosy", that is, he nosed his way into everything and avidly got to know all worth the knowledge. For short, his name was abbreviated to Bruz, and this became a household word, applied to people who asked too many questions. We children were often told to stop "bruzzing" when asking awkward questions.

At one time, poor Bruz had a slight illness, something of a nervous breakdown and placed himself under medical supervision. He soon returned home fit and well, bearing a certificate which verified that he was fully recovered and perfectly all right.

Anyone beaten in an argument in those days would try to re-establish himself if at the losing end, by asserting that the other fellow was not "right". This phrase, used in the local idiom, implied that you had a screw loose or you were a bit daft in the head.

Engaged in such a discussion with a friend one day, Bruz uttered some exaggeration to which the friend took exception, and was heatedly accused of being, "not raight".

"Ey 'owd on a minute," says Bruz, "What meks yuh think yo'are raight, don't forget I'm the only bloke in this place as 'as got a certificate ter say as 'eis raight, whot 'ev yo' got to prove as yo' are?"

His accuser was soon restored to good humour by this witty rebuke and the remark became a local classic.

Another gem on the roll of honour was "Shot Wright". He was a tall, gangling middle-aged man with a ginger-coloured walrus moustache. His name was always a great puzzle to me as it didn't seem to make any sense. Why Shot? Was it something to do with guns? I had to wait until I was in my teens to know the solution to this riddle.

My assumption proved to be very wrong in thinking it was to do with firearms. My father explained to me that when Shot was a young boy he had a remarkable talent for splitting the rear seam of his lower garment. This of course released his shirt tail to the light of day. Since the boy was such a familiar sight with his rear appendage and also because the local pronunciation of shirt was 'shot', Shot he became and Shot he remained.

Yet another was the Pikelet man Jacky Graves, a short sturdy fellow who pushed his covered handcart round the town calling his wares. He used to come round our way every Friday afternoon, without regard to what the state of the weather might be. He worked so hard and trundled so many miles during the week, that by the end of it he had worked up such a mighty thirst that he just had to let his hair down to recover from his labours. When work was done he took refuge at his favourite pub and got himself really well oiled, so well oiled he lay down on his belly on the tap room floor and sang "Yes, let me like a soldier fall upon a pint of beer." This was a parody of a song from a popular opera of the time. He created a great deal of amusement for the other patrons. They loved it. Though he didn't boast a nickname he joined the ranks of the famous by virtue of his calling and his special antics.

One amusing incident happened on a Christmas Eve when we decided to sample the conviviality of a neighbouring town during the festive season. It was quite natural that we chose a pub as we were now grown young men. It so happened, as is quite common, that raffle tickets were being hawked around and I was lucky enough to win a bottle of whisky.

It was our usual custom to share our winnings so I called for fresh glasses in order to despatch the bottle of whisky. As it was approaching closing time, we were already well primed with beer so the whisky really warmed us up.

15

There were four of us and we made short work of our task. Time was called, and after cheery good wishes to the rest of the company we sallied forth on to the street to make our way home. The fresh air outside made us feel a little heady so we decided to walk instead of taking a tram ride. We thought that by this means, we could at least walk our fuddle off and be able to stay on an even course by the time we got home.

The distance was about three miles and after many stops (for various reasons) we eventually reached our native market place, which was totally deserted—everybody had gone home. After kicking our 'dobs' (bowler hats) around a bit we realised that it was now Christmas morning and high time we were home. So we bid each other good night, two of us going home together one way, and the other two, who were brothers, going their way.

On reaching home, the younger of the brothers had occasion to visit the midden in somewhat of a hurry. The middens were always well away from the house well out of earshot. As our young imbiber failed to put in a reappearance within a reasonable time his brother decided to investigate. There he found him, the monarch of the midden, sitting on his throne complete with battered dob hat, and also wearing a smile of happy resignation. He was in a dreamless sleep and looked so peaceful that elder brother felt it best to leave him to wake up in his own good time.

Junior was quite a wag in his own right. He had a still younger brother who was larking about one day tossing a shilling in the air and catching it as it fell. Due to some misjudgement, and an open mouth, the shilling on its last descent disappeared down his throat and the resultant gulp did not eject it. He was in quite a quandary, his main concern being the loss of the precious shilling and its recovery.

After much physic and anxious observation, his patience was rewarded on the second day. There was the shilling good as new, a sight for sore eyes and, the restoration of his riches. The culmination of two days of worry was the ex-monarch's sage remark, "Never mind Tom" he said, "it's a damn good job that shilling worn't in coppers."

Schooldays and Games

My first recollection is of the terraced house which we occupied. It had a communal backyard with a solitary stand pipe to serve several families—there were no water taps. Sanitary arrangements were primitive.

I was only four years of age when we moved from there to a better place, but I still have a vague memory of a coal cellar grate.

When alluding to this some years later, my sister explained that I had a penchant for mother's scissors, and had a habit of toddling off with them to push them through the grating. After my family got used to this, they didn't bother to look in the street for the scissors, but lit a candle and went straight to the cellar to retrieve them. I suppose that it was less convenient if, for the sake of variety, I fancied the cellars of the neighbours.

Another of my early memories is of the very day we moved to the newly-built house some streets away. Quite soon after the flitting, I was to start my schooling, that nervous step from babyhood when the clocks begin to rule our lives. My elder brother and sister had weathered this as they were already there; my younger brother was only a baby and so had yet to face this ordeal.

The headmistress was an ogre, a spinster lady with no understanding of little children. She always struck me as being a woman who never really wanted to be celibate but would have preferred the love of a good man to enrich her life and fill her heart with love for her own children.

The other teachers were all lovely ladies, both married and single, and won the hearts of all their young pupils by kindness. I still remember two of the little songs that they taught us to sing at playtime, one something about 'Wallflowers, wallflowers standing up so high' and the other I remember word for word.

> Poor Sally sits a-weeping, a-weeping, a-weeping,
> Poor Sally sits a-weeping on a bright summer's day.
> She's weeping for her sister etc.
> And now she's got her sister etc.

I could still sing the tunes, and the thought of them brings back a little nostalgia. This is over 70 years ago. That idyll did not last very long, the sexes were parted and we went up to the boys to begin the real business.

In passing, I recall that, in the infants we were taught elementary English by chanting out what was termed as word building, often in unison. On occasions, one child would be singled out to perform alone as

a test. The idea of word building was to teach simple spelling thus—A—t At; C—at Cat; A—t At; B—at Bat and so on. It seems very amusing of course, but that's the way it was. One day we came to that massive, baffling word 'enough' Dear, dear—what a problem. The custom was, if you thought that you could do it, you put your hand up to the teacher and then she named her choice.

On this occasion—no hands! After a deathly pause, a lone hand sprang up in the air. A tall girl stood up—Eee-nuff enough; Eee-nuff enough—and went on until she was stopped. I was filled with admiration for this academic achievement, but as soon disillusioned. She could not spell it, not on your life. We later learned that she was not one of the brightest ones and had occupied that seat for some time, a stream of other kids meanwhile passing her by. As it was graduation year to the boys-only school for us, I never did know whether she ever vacated that seat before she was 13 or not. Poor kid!

In the boys' school we were taught mainly by men but there were some ladies too. Odd ones amongst the men were pure sadists and got a ghoulish pleasure from inflicting punishment on a boy.

There was only one in this particular school, but fortunately for my year, he had passed on to some other school a little previously, I knew of him from my elder brother who had often seen him in action. The only one I came across happened to be the head of the senior school I attended later. He was a really vicious little man and used to call us such nasty names as turnips and fisheyes. He could wield a cane like a galley slave driver and had such a fiendish leer he looked positively evil.

Most teachers were good patient people, conscientious and kind, but because boys will be boys, they were sometimes driven to the use of the cane. The rule for discipline then was, spare the rod — spoil the child, which of course was sometimes abused, though it must be said in fairness to them that they had plenty to put up with.

Basically we were taught the three Rs as they were called, that is reading, 'riting and 'rithmetic. There was no time wasting nonsense like football etc. during school hours!

When I was in standard four at about the age of 11, there was a great epidemic of peashooters. These were obtainable from 'Lucky Bags' and cost one halfpenny. This was not the smallest coin of the realm as there were plenty of farthings about.

Peashooters were fairly durable things, but peas were expendable and needed replacement, they cost money. To get round this problem we resorted to potatoes, sneaked from the domestic stock. We stuck the exit

end of the peashooter into the potato and extracted a small piece which then formed an airtight missile. They went off with a lovely pop.

When teacher's back was turned the bolder spirits took an occasional random shot. Boys, being artful little creatures, were not easily identified by the teacher when he turned again to face the class after hearing a report. Teacher's frequent turns to the blackboard and back gave others the opportunity to join in, but the scruffiest little boys can assume an innocent angelic expression if need be when under scrutiny so it was no easy matter to pin-point a culprit. Soon the whole class would be at it with pellets flying in every direction, aimed at other boys.

The potato stocks of the town went down at an alarming rate until the head decided to call a halt. He went round with a sack and ordered every boy to empty his pockets and roll down his stockings. When this violation of boys' rights was completed, he had a sackful of part potatoes and peashooters. I can see him now, walking out of the classroom with a sack on his back threatening all with dire consequences should ever another peashooter be found. The epidemic was over.

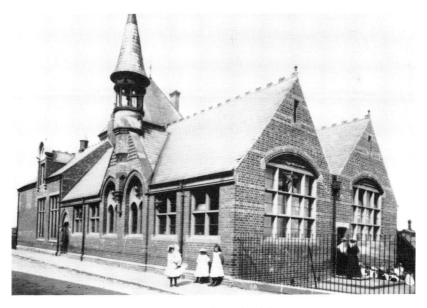

The Croft School, Hardwick Street.

In the playground at playtime, we invented our own games. Sometimes the biggest boy in the school would wedge himself into a corner where the boundary walls met and begin to chant "More on, more on!" Every other boy rushed from wherever he was and piled into the corner to form a struggling mass of arms and legs. Each boy took up the chant to the set rhythm and it swelled into a mighty roar that must have been heard at the other side of town.

Or we might play 'Dob'. This was a game in which you could soon get rid of any surplus energy. It went as follows: Two boys acted as captains to pick sides, one tossing a button, the other calling 'Back or belly' (of the button) for first pick. Alternately, they chose their men according to size and weight, to get a reasonably balanced result. Another toss of the button decided who was to be 'on'. The term 'being on' was applied to the unfortunate one or ones who usually suffered the worst pummelling, in any game whatsoever. The 'on' side then formed a kind of caterpillar, the leading boy standing with his back to a wall to act as a cushion (pity his poor tummy). The rest bent and tucked their heads between the legs of the one in front and so made a horizontal line of backs on which the other side were to leap. The first boy of the jumping side leapfrogged as far as possible to make room for his followers. On landing each boy tried to place himself as strategically as possible. The last boy to jump was usually the smallest and on landing had to recite:

Dob Rusticum Bum
2—4—6—8—10
Dobbin' off again.

There was guile in the smallest boy being the last as the heavier ones placed the maximum strain on their opponents for the longest length of time. The top lot hung on at all angles but tried to stick like grim death until the recitation was completed, then dismounted to go again—if no one fell off. If the caterpillar collapsed under the strain, they were still 'on' and had to continue until someone did fall off, as they were bound to very soon, the game was played with such gusto.

When one of the jumping side fell, the positions were reversed and so it went on. Many's the time the whole caboodle fell in a struggling heap of happy, laughing, grunting boys. I loved playing dob, it was rough but tremendous fun.

School was all right of course, but only up to a point. Still, there was always one's own liberty to look forward to, and it could not come soon enough. In fact, it came at 4 o'clock when off we went home for tea.

After tea, we children could play on the streets until bedtime, usually 8 or 9 o'clock. Games were varied and of our own invention, some probably passed down to us by older boys who, in their turn, had probably likewise inherited them.

A few that spring to mind were confined largely to the winter months as darkness was essential. One was 'Lurky.' All the group except one hid themselves in various parts of waste ground or neighbouring fields whilst the one who was 'on' counted up to 50. On reaching his target, he yelled 'Yip, Yip, Yallah, if you don't shout I shan't fallah (follow)'. Hearing a chorus of replies in the distance, his job was to locate and capture one. If he was successful, his victim was then 'on'. If he did not succeed, then it was just too bad.

The hiders of course, were expected to be fair and give an encouraging reply to every 'Yip Yip Yallah', but some were not averse to changing their location in the meantime. A similar game was 'Shine a light,' played with lanterns. Real lanterns cost money, a commodity that we did not possess, but we had a remarkable talent for improvisation. We made our own. All we needed was an empty fruit tin, often retrieved from the dustbin, and a piece of candle. Burnt fingers were incidental but were not too noticeable in the heat of the chase. The light was obscured by the flap of one's jacket, then revealed when necessary. It is a marvel that noboby ever got on fire.

Another game rather more mischievous, but for which darkness was absolutely imperative, for one's own safety, was 'The White Tailed Pony.' Though I am unable to explain the title, I can explain the procedure. The principal actor was always a boy who had recently moved to the area and was not aware of his real role. The victims were a couple of householders. The boy was persuaded to allow himself to be tied loosely by a length of string to a doorknob (by the wrist), everyone making sure that he could make his getaway with just a little struggle. Then a rope was securely tied to the knob and tautly extended to the next door knob and made fast. When that was done, the group parted into two bodies and soundly kicked both front doors to bring the occupants to see what was going on.

The kickers of course made off as fast as legs could carry them to some secluded point of vantage from which the fun could be clandestinely observed. It is easy to imagine what a lark it was, one man pulling at his door in opposition to his neighbour who would be doing likewise. The more they pulled, the more frustating it became, until finally the rope broke and they both landed on their bottoms. During this pantomime the

tethered boy had plenty of time to escape. The nearly-exhausted men would rush out fuming oaths, only to discover the 'White Pony' receding in the distance.

He was never caught, being far too fleet-footed for his would-be pursuers and as every other boy had by this time disappeared, the angry gentlemen would find only the silence of a graveyard and be compelled to retire in defeat. It was very unlikely, in view of the wisdom of hindsight, that a boy could be used a second time to impersonate a horse.

'Making the Bull Roar' was another diversion. We would stuff paper up the bottom of a house drain pipe and put a match to it, then make ourselves scarce. The heat generated by the burning paper, naturally caused a fierce draught of air to rush up the pipe and produce a roaring sound. I fear we sometimes unwittingly cracked a few pipes and had our parents known what we were up to, there would have been a few sore bottoms.

In the summertime we would extend our repertoire of games and pastimes. 'Dob', of course was an all-year-round affair as all the equipment needed was a convenient fence or lamp-post.

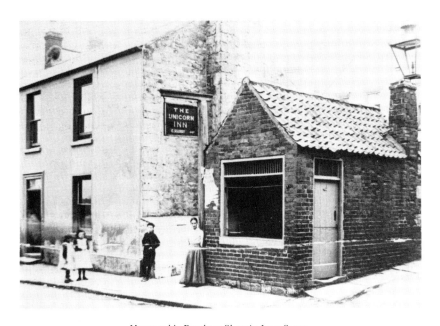

Hepworth's Butchers Shop in Low Street.

22

Some games called for more sophisticated equipment, football for instance. The problem was, we had the willing feet but not the ball nor the wherewithal to purchase it.

I have already said that we had the gift of improvisation. The solution was to make a journey to the butcher's on slaughter day and catch the first instalment of the Sunday dinner. We waited impatiently for the entry of the pigs. Our object was the pig's bladder. When the coveted object was available, one of the less finnicky of the party (somebody had to do it), would take charge of the bladder, grasping it by the neck and held as far away as possible, then proceed to the playing field with his retinue close on his heels, admiring this dangling thing with the eyes of true sportsmen, and pleasurable anticipation.

We would parade halfway through the town through any street on our route with no thought of modesty, our minds fixed only on the thought of a good kick around. From the various slaughter houses, pig's bladders could be seen travelling in all directions borne by an extended arm and propelled by two legs, and attended by a band of enthusiasts.

Our own venue was the 'Rec', and when we arrived there would be much rummaging in pockets for string with which to tie up the neck, but first, the bitter bit—it had to be blown up. There are no such things as pumps for pigs' bladders so the task must be performed orally, Uh! Some of us could never do that—I for one, even if it meant the end of my football career.

Happily, there was always some dedicated sportsman present who would screw up his eyes, pinch his nose and blow for dear life and the glory of the game. After the application of the string, all was ready, let battle commence, no rules and every man for himself.

As the 'ball' soared through the air it would give off a whistling sound caused by the flapping of strings of fat adhering to the sides. It really did soar as it was Rugby ball shape and its course was unpredictable.

One had to be very adroit when the trajectory of the bladder fell to face height as it had a disconcerting way of wrapping itself around things. However, despite all the little snags it was great fun.

At the end of play, which was usually when we got hungry, he that had carried it from the town was appointed custodian of the bladder until the next session. As each day passed our football became lighter and drier and more like parchment until it finally burst. This meant another trip to the butcher's, as the game had to go on in the interests of the national sport.

During the harvest season we had another diversion which could be termed both as a sport and a pastime. As it had an element of danger and daring about it (you might get caught) it had a special appeal to little boys. What normal boy can resist 'Scrumping'? It is the most natural thing in the world. I'll wager my father did it, I certainly did it, and I know my son had a go when he was a boy.

Scrumping called for good timing and a little careful planning in secret. The element of secrecy was a further attraction as we loved secret societies, the meetings of which were usually held in someone's toilet as the remoteness of the middens made their situation ideal though the atmosphere was not always perfect.

To us, nothing could surpass the thrill of cautiously climbing a wall or scrambling through a hedge to climb an "Everest" capped with apples or plums, then descending with bulging pockets to scurry away to a quiet spot and sample the spoils.

A frequent result of these excursions was of course tummy ache, but this was far outweighed by the spirit of adventure involved, a fact later proved, as we did not confine ourselves to just one expedition, the temptation of repeats being irresistible.

I remember only one occasion when we happened to be seen. The trees we raided happened to belong to my uncle, and Uncle Jay was a rather irascible fellow especially when he got to know that I was involved. You see, as a member of the family, I had an unfair advantage, for the day before, I had been with him to get some 'taters', and noted that his apples were in prime condition, and also noted a very convenient gap in the hedge.

My misdeed was duly reported to my father and the rest of the parents, most of it whom, as usual, ignored it, regarding it only as a boyish prank. Not so in my case. My father was a stickler for discipline and gave me a stern lecture as to the behaviour of little boys and especially of nephews of certain uncles. He could of course do little more than lecture me and certainly do no worse, as he may have spoken through a guilty conscience by recollections of his own boyhood thus stirred.

Had the owners of the fruit trees been a little more generous with their overladen trees and given away an apple or two to the children rather than let them rot on the ground, this poaching may have been much reduced, though not entirely eliminated as there would still remain the temptation of illicit tree-climbing.

Holidays and Whit. Walks

Though I am not sure, I believe our first halfday holiday of the school year was Ash Wednesday. We had some sketchy notion that it was to do with the church calendar but the only real significance it had for us was that we had a free afternoon.

The great day was the preceding one, Shrove Tuesday, better known to us as 'Pancake Day'. On this lone day of the year it was pancakes, and nothing but pancakes for dinner. During the morning at school, there was much speculation as to how many we could each put away when we had our knees under the table, as we seemed to have an idea that fame could be achieved through numbers.

There was a great deal of boasting in the afternoon, some kids claiming a round dozen, despatched in record time. Of course, we only had their word for it. I myself, never seemed to be able to manage more than two, though they were very tasty when garnished with orange juice and sugar. I fear the boasters were something other than big eaters.

Pancake day was also notable for bringing out the whips and tops for the boys and skipping ropes for the girls. It was rather odd how some pastimes were associated with just one time of the year and then disappeared into hibernation to re-appear at the same time the following year.

The next break would come at Easter when we had the usual week's holiday coupled with the annual penny chocolate Easter egg. This came as an added bonus to our weekly ha'penny. In our home, the ha'penny was given to us by our maiden aunt who lived with us (she was my mother's sister). But for her, there would have been no Saturday 'humbug' nor Saturday cinema; there were no spare coins in mother's purse.

The mint humbug deserves special mention. It was a huge piece of mint-flavoured boiled sweet almost as big as an apple—no boy had a mouth big enough to accommodate it. Inconveniently, it was not mounted on a stick, so one had two alternatives if reducing it to a manageable size; one to break it, (you'd need a hammer), the other, to lick it. The former method was criminally wasteful as bits could fly beyond recovery, so the latter was generally adopted—illustrating that we had learned our first lessons in economics and good husbandry.

It was a sticky job, I can assure you, but an artful licker, and subsequent sucker, could make it last from breakfast time until dinner time thereby making the best of the gifts of life. The process of course

25

produced many horrible contortions of little faces when the sucking part was reached. Boys and girls alike had a sudden attack of mumps which alternated from one side of the face to the other. Rosy complexions often assumed an alarming purple hue in the struggle for breath, but if one neared the point of expiring from choking, a good thump between the shoulder blades restored the sufferer to resume the battle of the humbug until it was no more. It was a blessing (though we did not appreciate it) that there was only one Saturday per week. Had there been seven, many a child would have been brought to an early grave as accidents are bound to happen sometime.

During the Easter holiday, we would get a rare boiled egg for breakfast. I say rare because mostly we had porridge and great hunks of bread dipped in bacon fat or the like, but in my house at any rate, we always got a bellyful and were never refused a morsel while-ever we could eat anymore. Some poor children were not so fortunate. Perhaps their parents had fallen on really bad times or were selfish and did not care. I used to feel sorry for some of the boys at school.

The poor little souls would appear in what could be termed no better than rags, their bare toes poking out of the end of battered boots, crab-ankled, knock-kneed, bow-legged, spindly and rickety. No one today would believe the abject poverty of some homes of the time.

Low Street, looking from Portland Square.

Malnutrition, lack of good sanitation, coupled perhaps with a slovenly housewife (you could get them in every generation) and general ignorance, took their toll.

My mother used to say "Soap and water costs nothing," but a few seemed not to have heard of these basic materials for cleanliness, so some of their misery was self-inflicted and sadly fell upon their helpless children. Tuberculosis was the main scourge of the time and processions to the cemetery were a common sight even in a small town, the most pathetic feature being that of tiny coffins, containing those who had made a bad draw in the lottery of life. Anyone can confirm this if they will pause to read the gravestones in old cemeteries and churchyards.

In school at Easter we were told the story of the resurrection, sang Easter hymns and, when dismissed, contritely determined to lead a better life and no more scrumping. While on the subject I would like to add that we had religious instruction every school morning. That began the day and laid the foundation of our future behaviour in teenage years and adulthood.

The next great festival was Whitsuntide, also a school holiday, which really centred on the Tuesday following Whit Sunday. The birth pangs for this event often began for parents weeks or even months before, by scratching pennies to lodge in some clothing club. For some, the pangs remained after the event, periodically alleviated by visits to the pawnshop.

Every kid in town had to have his new annual rigout, it was the done thing, it was a matter of parental pride, no matter what the effort. In the preceding week, every clothes shop in town was packed to suffocation trying this and that on the children, and the streets were busy, with people carrying parcels. Purchasers took great care that the clothes were 'a nice easy fit' as they knew that no matter how much they grew, the children would get no more for twelve months.

The clothes phenomenon made its debut on the Sunday, all the kids dressed to kill. The custom was to go and show yourself off to aunts, uncles and grandmas, in the hope they would give you a copper as a compliment for your smart appearance, though my father always strictly forbade us to take such gratuities, as he called it "cadging" something very much beneath his dignity.

My wife used to tell me that her mother was just the same. That I can well believe as even today she has the pride and dignity of a Queen, old as she is. I sometimes questioned the wisdom of my parents' logic as we were forbidden even to accept a halfpenny from a neighbour or anybody for that matter, for the running of an errand, but were instructed to take a

piece of cake if offered, for the sake of good manners. The cake was usually carraway seed cake. I hated the damn stuff but had to swallow it with what grace I could summon. I thought that it was invented for the torture of boys, particularly me.

On this Sunday morning of the year, an unusual sound would pervade the town, coming from the feet of juvenile prospectors in search of a fortune. Why did new boots always squeak? They do not do it now—that makes me wonder all the more. It sounded as if the town had been invaded by a plague of crickets or grasshoppers, but usually any stranger visiting the place would swear that it was the most prosperous town in the country, the kids all clean and dressed-up, and proclaiming the fact that the local pawnbrokers would be awful busy the following week.

One more day to go and then the great day of the 'walkround'. Tuesday dawned to feverish activity, children scrubbed, polished and adorned in their finery, were packed off to their respective Sunday schools to 'walkround' in witness of their faith. The chapels walked in the morning, the churches in the afternoon. This rather childish division was, I thought, the product of a little snobbery on the part of the orthodox churches, but we were just as proud of our free church as they were of theirs. In the changed world of today since the 1939 war, they all walk together and do so on the Sunday.

After a little briefing, the procession would be formed, headed by a brass band and a banner of the church, each and every one supplied with a word sheet of the hymns to be sung on the market place where all were to assemble. Naturally all the churches lay in different spots so each had its set route and quite a number of streets were full of bands, walkers and watchers.

It was a very colourful procession and wonderfully exciting for children. Sweet little girls and young ladies dressed in their frills and furbelows, hair tied in ribbons, looked for all the world that butter would not melt in their mouths. The boys with beaming, shining innocence, could not possibly be the raiders of orchards in the coming autumn, not bull roarers or organisers of an equestrian sport for pale ponies. They were gazed upon by adoring mothers, on their day of glory, who would nudge their neighbours (both sides) and say in rapt tones "Look! There's our Willie", but the fathers would more likely wear a wry smile and think "Ah, I know that little devil, I once stood in his boots."

In due course, all were gathered on the market place where at the bottom stood a platform supported by empty beer barrels, on which awaited the elders and parsons of the various churches. Each year in turn,

one clergyman was appointed to conduct a short service and announce the hymns that everybody was waiting for. So many people were present that not another could have found space, including visitors from surrounding places.

Not a solitary house in town would contain one living soul unless through illness or some such cause. All the people from the Church of England were there as spectators ready to make their way home as best they could through the dense crowd immediately the singing was over, in order to prepare for their own walk in the afternoon. Whilst the parade was marshalled into some kind of order, the now-resting bandsmen downed their instruments and stood with a pint pot of beer and drowned that too, more than once replenished. (There was a pub at each corner of the market place).

A selected band arranged themselves to play the hymns and all was ready. After a few introductory remarks the singing would begin. Everybody knows hymns and all joined in. Imagine the sound that came from thousands of throats singing with enthusiasm and fervour. It must have been heard miles away, and the quiet hush between one hymn and the announcement of the next added its own kind of drama.

God in His heaven must have heard it and blessed all those present. It really was beautiful and impressive. At the end of the service, each Sunday school would take the shortest or most convenient route back to their schools and everyone concerned would receive a bun and probably more to give to someone unable to attend. These buns, though only what are generally called teacakes, were much coveted for their significance. They were no ordinary buns, they were 'Whitsuntide buns'.

In the return parade, all starting from one spot, the bands would strike up one after the other, and feet begin to shuffle off, so that a great cacophony of sound arose, bands and drums vying one with the other, with an underlying squeak of thousands of new boots. The whole performance was repeated in the afternoon by the onlookers of the morning, the roles being reversed, with the same moving sound of the singing of a different set of hymns. After tea, all the children were entertained on some field or other and so ended a wonderful day.

After Whitsuntide, all new clothes were neatly folded and carefully placed in drawers to be worn only on Sundays and very special occasions, until the next walking round the following year. Last year's new clothes would be relegated to schoolwear, schoolwear to playwear, playwear to the ragman or to finish its life in a pegged rug to be worn to dust and to disappear finally into nothingness. Nothing was wasted.

Christmas

The end of nutting brought us near to Christmas, that magical time for children which means carols and Santa Claus. The scene was set two or three weeks preceding breaking up time for the holiday, by making garlands and lanterns to decorate the schoolroom. We were told Christmas stories and taught the meaning of Christmas, and everything culminated in a party with games and carol singing, much as is the custom today, excepting perhaps that we took all our own food—every crumb of it, also cup and saucer, plate and spoon and wobbled all the way to school with a custard and jelly, looking like a pack horse on a tight rope.

At home in the meantime, hundreds of hopeful letters to Santa went on the fire, to be sent up the chimney as smoke to the mysterious giver of childish delights. We sent extravagant requests for bicycles, prams, dolls, roller skates and all manner of things, but though the fire was kept a-glowing with lavishly fed notes, and a perpetual stream of charred paper went up the chimney, nothing much ever seemed to come down.

However, we really did believe in Santa Claus and each succeeding year, up went notes regardless, full of faith and hope—perhaps he would start at our end this year with a bagfull. Hope springs eternal so Christmas Eve brought feverish excitement and breathtaking anticipation. Off to bed we would go, with candlestick and lighted candle, also carrying the largest empty stocking we could lay our hands on to hang on to the bed knobs.

My two brothers and myself would tumble into bed, the three of us together, and speculate on the morrow. Soon someone would come upstairs to blow out the candle and make sure all was safe for the night, enjoining us to be quiet and assuring us that Santa only visited sleeping children. This would work the trick as we were already half dead under the strain of being at the mercy of a bewhiskered gentleman who could be generous or otherwise.

On awakening early, very early, next morning, there would be a rush to respective bed posts to discover our fortune. Alas, year after year, we would find an orange, an apple, a bag of sweets (these were an unusual treat), perhaps a drawing book or a game of 'Snakes and Ladders' but one small consolation would be a lovely shiny bright new penny.

"What's wrong with this Santa feller?" I used to think, "we're last again." Here was this Christmas fairy, riding through the sky complete with reindeer, sleigh and bells who came down the chimneys to shower little children with presents.

He couldn't have forgotten what we wanted for he'd had too many notes to remind him, and granting that he might even be a little absent-minded, such a shoal of paper ash had ascended our chimney that his whiskers must have picked up the residue of what could not possibly have been dispersed even by a whirlwind—this surely should serve as a jolt to his memory.

The Santa Claus chap was a great enigma to me. Though our chimney looked like all the rest, there must have been something wrong with it. It had a kink perhaps and would not admit the passage of a bike, and the aperture was so small that nothing bigger than an orange could be persuaded to make the drop. The puzzle intensified later in the day when I would see the proud owner of a brand new bike, or another lucky one trying to break his neck in an effort to master the intricacies of roller skating.

Our parents had some awkward questions to answer when we took back a report of our various sightings. In belated explanation, they would point out that so and so else's father had a good job and that he had no other offspring. This raised another query—what had Mums and Dads to do with it, it was Santa Claus who did the dishing out? Why did he have

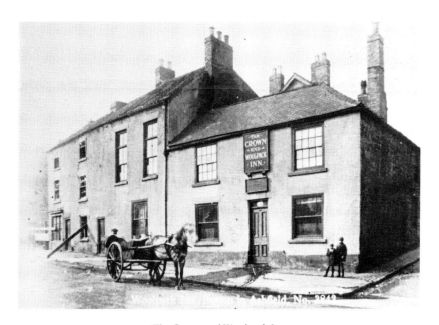

The Crown and Woolpack Inn.

31

the same favourites time and time again? When we began to realise that third parties were involved, it rather shattered the illusion so romantically built up so we rapidly began to lose faith in Santa and saw him for what he was—just a fake and a fairy tale.

Like most other children, we took our little disappointments stoically and realised we had each other and that our sister was worth more to us than all the bikes in Christendom—though she did have her faults when she made us wash, and clean our teeth. We had at least someone to play snakes and ladders with, but the poor unfortunate with the bike had no one to hold it for him while he cocked his leg over the saddle on his first trial run. The fact that he needed an assistant was of course to the advantage of would-be riders who hitherto had to walk.

Yes! We would oblige—if we too could have a go. Boys who had no brothers or sisters seemed less venturesome than others and were largely ignored for that reason, apart from other reasons, but they became of importance and subjects for attention and high regard if they possessed a bike, or a football, or some other coveted object.

A first riding lesson might proceed as follows—the teacher (who couldn't himself ride), would firmly hold the bike for his pupil owner to mount the machine, then gently push him along still holding on to the saddle. When the patience of the instructor ran out (which didn't take very long), he could always give the rider a shake or two to make him perform a few complicated figure eights, or he could let go altogether and let him fall off with a bump. This was, of course, a pure "accident" vowed the instructor, but after this kind of treatment, the owner's enthusiasm was dampened and he became more amenable to a change of riders. By such devious means non-owners learned to ride.

I remember one boy (an only child) who had the lot—bike, football, cricket bat and things too numerous to mention. This catalogue of possessions elevated him to a position of great power. Being the owner gave him the privilege of choosing who played and who didn't. On the day, he was very popular with the chosen few, but the rejects temporarily out of favour would walk away in disgust and resort to the jointly-owned pig's bladder—it was more fun anyway.

Naturally, when his ball was bust, his popularity waned and things went back to normal until such time as the cricket season arrived and we could make use of his bat until that, too, went the way of the football. This boy was so pampered by his parents that they turned him out on a Sunday with stiff shirt cuffs and a fancy walking stick, ponced up like a tailor's dummy, so making him an object of ridicule for the other boys. Though I

sometimes envied his affluence, I wouldn't have stepped into his shoes for anything. I felt sorry for him. Without his trimmings, he was a lone figure.

As I have already said, we were stoics and any delusions about Christmas stockings were soon forgotten. Christmas is essentially a children's festival, built around the home and if we got little in the way of presents we made the best of what we did get. Is there anything quite like the old English Christmas as we knew it? I can only recall it through the eyes of a child, but to me it was sheer magic.

Great roaring fires with glowing coals piled up to the very throat of the chimney, and after dinner, chestnuts popping off on the oven top. On that day, the king of England was no better off than we. He'd only had his dinner just the same as us, and his dinner could be no better than ours.

There was the Christmas tree, the garlands, carol singing and it was a time for laughter and backslapping, everybody blessing everybody else. After Boxing Day it was all over, the men back to work and everything as before.

We would be allowed to stay up until midnight on New Year's Eve, to hear the church bells ring out the old and ring in the new. Thus passed another year.

Hearth-rug bath

On reaching home, many children would be greeted with a very familiar sight, if the father was a miner. There before a roaring fire would be a zinc bath, the man stripped to his waist and the wife scrubbing his back with a brush, using plenty of soap and hot water drawn from the boiler beside the fire.

The water had to be put into the bath by saucepan or ladle, a measure at a time. When his back was restored to its normal colour, he could finish off the rest himself if he was not too tired.

Many's the time I have seen a man fast asleep in his pit trousers, lying on the rug, having been too exhausted to stay awake or even move to another spot.

33

The Penny Emma

She was one of the poorer sisters and though she coughed and spluttered in an asthmatical way she was beloved of every man, woman and child in the parish of Sutton. She had a heart; she was a living thing. Emma plied the mile of line between Sutton Town Station and the Junction Station carrying both passengers and freight.

Sometimes she made the journey alone, to pick up freight wagons which on return were shunted into the Town sidings. On these occasions, having nothing to pull she gave off an odd, sort-of-empty, metallic sound like that if an old clothes mangle being turned without a load. It gave the impression that she carried but a bucketful of coal in the tender, a pint of water in the boiler—and that the firebox was fed with a teaspoon. Yet she could give off a mighty belch of black smoke when getting into motion.

Having served the town for so many years, if this darling of the iron road could have spoken she could have told part of the history of Sutton— of the children on the Hardwick Lane recreation ground pausing in their play to wave to the driver who always acknowledged the salute—of Sutton Town Cricket Club at play on the next field, some of whose

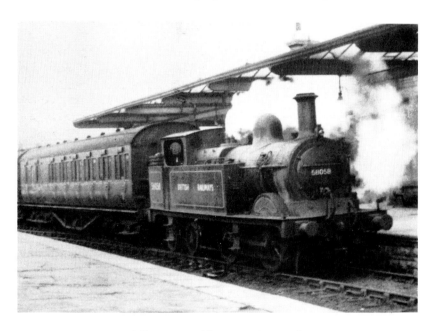

"She was one of the poorer sisters . . ."

34

stalwarts graduated to County Cricket, including the famous 'Topsy Wass' the terror of many a batsman, especially on an occasion at Trent Bridge when a reverend gentleman stubbornly refused to get out to the other bowlers, which prompted Topsy to ask for the ball, remarking: "I'll soon upset 'is bloody pulpit." He was not famous for his etiquette or his choice of words. On the next field were 'The Reds,' Sutton Junction Football Club. Martyn Avenue was built on the two latter-mentioned fields about 1920-21.

After taking the gentle curve in the line the Junction would come into view and it was time to put the brakes on and blow the whistle to announce the arrival, and so roll up to the buffers in sedate manner.

After shedding her cargo. Emma could not fail to notice the 'man about town' making his way towards the footbridge which gave access to the Nottingham platform. From the soles of his boots to the top of his head this worthy was the picture of elegance. The uppers of his boots were encased in a pair of light grey spats. His narrowish trousers fell well over his insteps. His jacket, of loose cut, hung almost down to his knees like a half frock-coat—the lapels were short and high cut allowing an ascending row of buttons to reach the middle of his chest—all buttoned up but still revealing a glimpse of a white shirt front surmounted by a high standing white linen starched collar, which made him hold his chin up and so added to his proud appearance.

He wore a grey bowler hat and carried a malacca cane walking stick, decorated with an engraved silver band. This was not all. Beneath his nose he sported a magnificent black 'tache, waxed and twisted at the ends, which were turned up to form two perfect semi-circles. He looked for all the world as though two giant tadpoles had met head-on on his upper lip, and were curling their tails in anger. He was the perfect Edwardian masher, a positive lady-killer.

Following him was a young man still with a few specks of confetti on his shoulders, bearing a young lady on his arm, wed that very morning. What Emma had not seen had happened behind her back on the way down. She had not seen the furtive looks, the little hugs and squeezes and the nervous brush of lips on a blushing cheek—but she did see our bride hitch up her flowing skirt a little to ascend the steps of that pretty bridge (all diamond patterned and steel tracery).

In so doing she revealed a pair of dainty ankles and thus with arms akimbo show a waist so delicate as to rival that of any Dresden china lady that graced many a mantelpiece. On reaching the apex of the bridge it seemed that the sails of Addlington's Mill waved them a gentle God Speed.

35

See there—see that heavy jowled florid man dressed in a loud checked suit with cap to match, whose jacket could not contain his generous corporation and so displayed a waistcoat with a heavy gold watch chain suspended from pocket to pocket, one of which hid a gold 'half hunter' and the other a silver snuff box. It took no clever man to guess that he was off to the Nottingham Races.

As the station cleared and the porters assembled parcels and small packages, a tall gaunt man with a small goatee growth on his lower lip appeared on the platform, and with a brief wave to Emma's driver he set about loading the same on to his pony trap which stood outside.

This was Carrier Jepson, a familiar figure who daily plodded up and down Station Road. On his way, he might meet a short, stout man leading a horse and cart. Sticking out from and above the sides of the cart would be four grotesquely stiff legs. The leader of the horse was Mick Heathcote, wearing his 'looking glass' waistcoat—the shine of which was produced by the residues of his trade. The horse was taking one of his deceased brethren on his last journey. The destination was the Portland manure works which were owned by Mr. Heathcote.

Should one be about of an evening, anywhere between his residence just beyond the top of Oatses Hill, and the Town Hall, he could be seen on his way to the pictures carrying a cushion under his arm. This worthy gentleman did not relish the prospect of two hours on the hard seats of the threepennies.

On July Feast Saturday, Emma was the means of launching the lucky few on the first lap of their journey to Blackpool. The train was packed with Mums and Dads, excited children, buckets and spades, brollies and walking sticks—apart from sundry bags and suitcases. The departure had the appearance of a general exodus and one wondered if anything was left at home. They were waved off by a company of little boys standing by the barrows which they had used to push innumerable suitcases halfway across the town at a penny a time.

The following Saturday, Emma would trundle down to the Junction to pick up a rather more subdued party of ex-holidaymakers, but cheerful enough at the prospect of giving their friends the sticks of rock that they clutched beneath their arms.

The parents brought back the latest songs sung on the sands by the beach concert parties— 'Alexander's Ragtime Band,' 'Everybody's doing it' etc..., and as the songs spread from mouth to mouth the bathtime music of the town was richly replenished. My elder brother was a great one for singing 'I'm forever blowing bubbles' when taking his

bath, and his lusty whistling of 'Nellie Dean' would stop any passerby. I never indulged in this practice myself, not because I never took a bath but because I had neither voice nor whistle.

The children had tales to tell of their first sight of the sea and I remember one boy named Ronnie Bowen, still full of wonderment, dramatically informing his friends "Thizz iver such a lot a'watter theer."

Emma was very familiar with the railway drays that passed in and out of the goods yard drawn by splendid shire horses—great, noble beasts with flowing manes, swishing tails and swirling fetlocks, clad in harness polished to such brilliance that they almost made the beholders blink. She would remember the day in about 1912, when Lloyd George delivered a speech to a huge crowd on the Lawn pleasure grounds. I was there, with my father, and there followed in his wake a band of suffragettes who caused a tremendous sensation but little harm.

The most dramatic event during the many years of Emma's long service must be the 1914 war, which began for us at Sutton when the local unit of territorials were mobilised to the colours. On that day, Emma took no part in their transportation. They transported themselves.

Whichever end of the line she may have been, Emma must have heard a faint murmur from the market place and perhaps a muffled word of command—again I was there. Then, the sound of marching feet coming ever nearer, accompanied by us children who trotted behind and beside them, all the way down Station Road to Sutton Junction.

These young men were stockingers, miners, plumbers, shop workers and men of every trade—marching gaily off to a war with a predicted duration of no more than six months. How tragic that prediction proved to be. Gathered at the station were mothers, sweethearts and children, all the womenfolk trying to put on a brave face. Before the movement of entrainment decorum was thrown to the winds and there were many tearful and unashamed embraces.

"Never mind" said the young men. "We'll be back for Christmas," What a vain hope—for some on that train were destined never to grow old.

For the duration of the war, Emma carried many soldiers on leave—some wearing 'hospital blue,' and of course our contribution of sailors. As they stepped off the mainline train and saw her waiting there, they must have felt that now they were really home.

She was part of the town—she was Sutton. Maybe up and down the country on many local branch lines, her counterparts served a similar community: but to the people of Sutton there was only one Emma in this land.

Gospellers

In the early days of the 20th century, the working classes of Britain laboured long and hard for little reward. Leisure for them was yet to be invented. Their respite from weekly toil came on the Sabbath.

On this day, many fathers recovered their Sunday suits from mothballs, spruced themselves up and took their family to the church of their choice. There being little else to do, they felt this to be a more gainful way of spending their free time—rather than getting into mischief, bearing in mind especially the children.

Maybe grandma tagged on to the rear of the party, bedecked in her Sunday best—a long, black dress which reached to her ankles, with puffed sleeves and ruckled bodice surmounted by a shoulder cape, all this crowned with a bonnet of the same funereal colour. Bodice, cape and bonnet were bespeckled with sequins whose every facet reflected the light, and grandma sparkled and glittered like an elaborate candelabra. Summer and winter she carried an umbrella.

Her rearguard position in the party was strategical, her umbrella armorial—so that in both senses she was perfectly equipped to urge along reluctant little boys. Little girls in those days were all sugar and spice but their brothers were considered to be a severe trial. However, grandma was determined that her progeny be pressed forward towards the golden gates. Grandfather, having learned many lessons, probably stayed at home and smoked his pipe. Without wishing to disparage any church, I do feel that the singing and social side of the business attracted more people than did the weekly spiritual ablutions.

This sociability sometimes extended to other nights of the week—choir practice for some, Sunday School concerts rehearsals, preparations for bazaars and the like for others. Should the flock be considered to be getting a little out of hand with all this hilarity, the parson would administer a dose of medicine in the shape of a hot gospeller or a missionary meeting. In my memory, the most famous hot gospeller to visit Sutton was Gipsy Smith. All others were lesser fry.

'The Gipsy' was a florid man, heavily built with a generous corporation, bull-necked and heavy jowled. He had grey hair and a whisky nose; I would think him to be in his sixties at that time. Whatever abstentions he may have practised, eating was certainly not among them. This gentleman stalked the land rallying erring sinners to the banner, pausing at the Congregational Church to rescue Sutton-in-Ashfield from threatened damnation.

He brought his own circus with him—two tall, angular ladies clad in long white dresses and two taller and more angular men dressed in black. They were supplemented by a similar gent on the piano. Their function was to ram home the message in song.

The congregation—or should I say audience?—already assembled, forgot their laryngitis and stopped clearing throats immediately upon the appearance of the troupe. In the pews, men adopted their most sober expression and the fat ladies shuffled and settled like broody hens on their clutches. A portenous silence reigned.

After a few preliminaries, Gipsy would sing (unaccompanied) a bit of doggerel with a tune to match, surely of his own composition. There would be several of these but the only one of which I remember both words and tune, is:

> Believe in the Lord Jesus Christ,
> Believe in the Lord Jesus Christ,
> Believe in the Lord Jesus Christ
> And thou shalt be saved.

His assistants would join him in repeats until his listeners had thoroughly absorbed it. Then came the great ensemble, the climax of the music lesson, the concerted effort of hundreds of lungs. During this mighty chorus, collection plates passed up and down pews, and hundreds of pennies tinkled their own music. Even those seated in the window bottoms could not escape the plates. This metallic music transformed Gipsy's expression from the benign to the ecstatic; many future dinners were assured.

At the conclusion, laryngitis again seized the multitude like a new epidemic as they coughed and spluttered their way to freedom. Some who neglected to wipe their feet on entry were observed to rub their feet vigorously on exit as if to leave the dust of Zion on the doormat. Many of the less impressionable resolved to postpone their salvation to a later date remarking "Well it worn't ter bad, it could a' been woss."

Missionary meetings were another diversion. The speakers were usually serious young men full of zeal, newly graduated from college and perhaps recently ordained. They were required to win their ecclesiastical spurs in Darkest Africa; their immediate object at the meeting was to obtain support for the project.

All females present above the age of five were strongly pressed to knit socks for black sweaty feet that would have been more comfortable encased in blocks of ice (even flies would not settle on ice!) He would go on to tell of poor coloured people dwelling on the equator who had never

heard of a shirt, and ran around—man, woman and child—in their birthday suits. This was greeted by the youngsters with "Goodie-Goodie" and gave birth to their first thoughts of emigration, and by the staid matrons with disgust, and by the black frock-coated parson with shocked abhorrence.

Our missionary proposed to go on a crusade to fight these evils and his weapons were to be shirts, blankets and socks. This demanded the knitting up of many miles of wool, assiduous sewing of shirts and the collection of millions of coppers to provide blankets to make hot natives hotter still. To youngsters like me, this posed a great conundrum. We could have a penny for the missionary box but we could not have a penny for a mint humbug, wheedle as we might. It grieved me to think of all those mint humbugs that disappeared into the bulging coffers of the missionary society.

Many a domestic mantelpiece supported a box with a slot on the top which allowed easy access for pennies, but one needed a tin opener to get them out—consequently you gave the tin a wide berth and pretended you could not read what it said on the label.

We were continually bombarded with this type of propaganda and what with Sunday School, Band of Hope, Christian Endeavour on the one hand, and Charlie Chaplin and Buster Keaton at the pictures on the other (where you were sure to get a good belly laugh) life was proving to be a very complex affair.

"Mis-spent youth"

The chapels viewed dancing and the frequenting of billiard halls by boys with abhorrence. (The latter it was said, was a sign of a mis-spent youth). I must admit, I mis-spent some of my youth in 'Pep' Hepworth's hall on Outram Street, almost opposite what was then the Wesleyan Chapel. Shame!

Brake Ride

After Whitsuntide, we had the 'Wakes' to look forward to in July, but that being a few weeks hence, things could happen in between if we were lucky. A few, born under a lucky star, might even enjoy the luxury of being taken to the seaside on a day trip by train. (I had to wait until I was sixteen to see the sea, and would not have seen it then had I not saved all the year round and paid for myself, only made possible because I had been at work for three and a half years by then).

What we did get at our house was an annual brake ride. We were told the date a few days before. We could never have survived the excitement for longer.

On the chosen morning Grandma would put on her sequinned black bonnet and cape, her best linker boots and finest gown, then sit in majesty on the sofa with a benevolent smile for her excited, second generation brood, whose exuberance was approaching boiling point.

After, the children were got ready; the girls, heads curled and be-ribboned, and wearing a cotton print summer frock; the boys closely cropped hair plastered down with precision, their unfortunate necks imprisioned in a starched linen Eton collar, then the ensemble completed with knickerbockers, black stockings and stout boots, with the appendage of a cap.

When the lunches were packed, everybody awaited the hired brake, expected sharp after breakfast time. Uncle Jay was a very horsey man, he knew one from tip to tail and was a skilful horseman. He could handle a pair with ease. When a brake appeared with Uncle holding the reins, we knew it was ours. There he would sit, resplendent in brown leather leggings, polished to a dazzling brilliance, his ruddy face glistening and beaming, intent that his sisters and their husbands, his nephews and nieces had a day to remember.

The brown leggings were for high days and holidays only. Black ones sufficed for ordinary days, often covered in horse manure or pig muck (we lads knew, as apart from seeing them, we often had the honour of cleaning them). He was not a farmer, but always had a few ponies, pigs and poultry. He had a real talent with horses and made more money in a week horse-dealing, than my father made in a couple of months. Being childless, he was not without a copper. This outing was a family affair, perhaps twenty of us, and he would shepherd us all on to the brake, two beautifully groomed horses meanwhile stamping and pawing to be off.

41

Uncle was a short, fat, florid man, full of his own importance, dark hair parted down the middle and plastered down with lard. He had a photograph of himself in his living room and would proudly point it out to us saying "That's the best looking man in town."

He never brought Aunty Mary Ann on these trips as she would be busy running the little shop that they had. When all were safely aboard, off we would go. There was great rivalry between the boys as to which two would sit beside Uncle on the driving seat. My elder brother, being named after him, always got the coveted position, unfairly we thought. After all, we could not all be Jays, but we had the consolation of knowing that in turn, we could occupy third place. It was marvellous and thrilling to have a front seat behind those proud nodding heads, bells and brasses tinkling on their harness, great shoulders moving with the rhythm of every step, pulling a load without it seeming any effort.

Velvety shining flanks, powerful rippling haunches with tails swishing to ward off the flies, the clop of hooves and grind of iron tyred wheels sometimes accompannied by a little whinnying and snorting of those lovely animals.

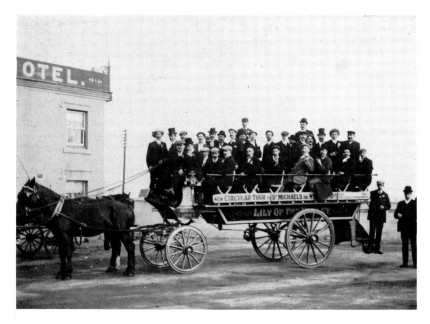

A brake like Uncle Jay's.

The whole set-up was romantic and endearing—poetry in motion. The town was so small that it seemed but a few turns of the wheels and we were in the countryside. Down dusty winding roads, a surprise round every bend, we had the time to look and nothing seemed a long way off, no long endless stretches. Up a little hill, down again, every road bordered with hawthorn hedges interspersed with blackthorn, dog roses, festooned with ivy, bindweed and all manner of climbing plants. Grassy road verges thick with wild flowers, tall ones reaching for the sun, shade lovers at their feet, each plant in its own habitat, nothing apart from the hedges arranged by man.

This was nature's garden. The roadsides would be dotted with gnarled oaks, majestic ashes, sycamores and elms, and if the road made its way through a bit of woodland, slender silver birches and mighty chestnuts decorated the landscape. The fields were a hodge podge of shape and size, sometimes containing a little coppice, and had little corners (if they could be called corners), of outlandish shape.

Boundaries seemed to wander everywhere, hence the winding roads. Nothing was geometrical, so everything had a softness which straight lines cannot achieve. Birds whistled, cows lowed, sheep bleated, and this symphony of nature added to the peace and serenity of it all. The air was scented with the perfume of the countryside and the smell of new mown hay.

The whole picture was a patchwork tapestry of beauty. The horses jogged along gently until Uncle decided that they should be rested, so we would draw to the roadside for the horses to pluck at the verge and we all dismounted to stretch our legs, then off again through pretty villages with narrow ambling streets, to our objective for lunch. This would be some country inn yard where there would always be a horse trough and stables, the latter of course little used, as the days of coaching were long gone. The horses were watered and fed while we had lunch, washed down with lemonade for the kids and beer for the grown ups if they preferred it.

Needless to say, all the men did, and some of the ladies might have a glass. I remember us once going to Southwell and seeing the cathedral, but as it was a fruit-growing area, I was more impressed with the size of the orchards and thought what a perfect paradise it would be for scrumpers.

After lunch and a bit of play, and gossip, the return journey would be interrupted for refreshment at some inn and we would get home in the evening having had a perfect day.

43

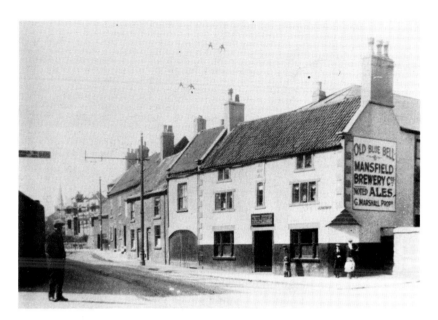

The Old Blue Bell.

"Tittling"

Until 'Wakes' came, we would pass our leisure time going walks round the meadows and lanes picking wild flowers, the girls making daisy chains, the boys scrambling in hedges looking for nests. We often went fishing for sticklebacks with net and jam-jar, taking off boots and stockings to have a paddle at the same time.

The brook was quite near to us, just over a railway cutting and a couple of fields. The brook was known as the 'Tittle Brook' as we called the small fish 'tittles', so of course we went tittling, not fishing like lesser mortals.

Sutton Wakes

About the middle of July many Sutton ladies purchased a ham—not a slice nor half a ham, but a whole.

Out came the great oval-shaped iron cauldron which was large enough to bridge the space between the boiler and the oven and sit firmly over the fire grate. It could comfortably accommodate the ham. After simmering for hours the ham was put on a huge meat dish, then lodged in the pantry to await its demolition during the following days. Some households also sported a barrel of beer, as feast week was the annual holiday for by far most of the workers of Sutton and they knew they had plenty of time to drink it.

On the Thursday prior to the Friday opening, a cavalcade approached the town, part of it from Skegby whose Wakes were held the week before. Some came up Station Road, where from I don't know, but for us children at the Hardwick Lane end this contingent would be our first sighting.

Juvenile enthusiasts at the New Cross end spotted the Skegby lot— They're 'ere, Wakes 'us cum'—the news spread like a forest fire. This was not to be missed. Houses disgorged their children as if by a given signal— children bent on escorting the procession to one of the fair grounds. There were two grounds. Chambers' Croft and Gelly's Croft. (I wonder—could the much larger town of Mansfield boast **two** fairgrounds.)

Each procession would be headed by a great road steam engine equipped with a flywheel that drove the two huge rear road wheels and they moved at about the pace of a leisurely trotting pony which made it possible for the children to keep up with it. The engine hauled a train of wagons bearing the larger roundabouts—cranky horses, dragons and the like and one would carry the centrepiece of every self-respecting fair, the thing that gives a fairground its very own special flavour—the mighty Steam Organ.

Usually, our lot chose to follow 'Johnny Proctors' to Chambers' Croft; others preferred to escort 'Hollands' to Gelly's Croft.

Interspersed in the wagon train was a variety of rolling stock, drawn by horses—smaller vehicles carrying 'Hoop-la' stalls, coconut stalls, tents and the rest of the regalia of a fair including gaily-painted caravans, large and small, the (what appeared to us) romantic dwellings of these nomadic people.

The caravans were spick and span inside and out and the small cooking grates and every bit of brass in the interior was burnished and

D 45

polished to gleaming, glittering brilliance. The horses were in like condition and left a trail of droppings in their wake that could be traced back to their point of departure at the beginning of the trek. This trail would be cleared up at no expense to the local council as eager boys would soon appear with barrow and dustpan to gather this bonus for Dad's allotment or back garden.

On Chambers' Croft we watched them unload and erect a miniature wonderland, for what had been just a green meadow now became a field of magic and romance. Children are ingenuous creatures of imagination—they can conjure up a mythical world of their own from the simplest of things, they even talk to fairies and flowers, and when I think of those distant days, I see us all standing there full of excitement and wonder, gazing at those glassy-eyed, snarling dragons made of wood, which, at any moment might belch with fire and flame. Yes, we stood there until the last bolt was driven home and all was ready for the morrow.

In those far-off days, villages and small towns were quiet places, quite unlike today. The only sounds in the streets were the rumble of cartwheels and the clip-clop of horseshoes, perhaps the cry of the solitary hawker and on rare occasions the raucous voice and the bell of the town crier—Charlie Scott—whose most frequent announcement was "Oh yez! Oh yez!—fill yer buckits 'un bowls, t'watter gooin' ter bi tonned off fer tew hours." This announcement was the prelude to the hiss of taps, the rattle of buckets and bowls and the empty street echoed Charlie's voice so that if you missed the message for the first time, you had the opportunity of a second and third hearing; then peace returned.

Under these conditions on this feast Friday evening, no one needed to be told that the Wakes had started, you could hear them, all over the town. Chambers' Croft vied with Gelly's, Proctors organs challenged Hollands and the faint ring of wooden balls hitting the metal backing of coconut stalls could be heard in the distance.

The town that hitherto slumbered in the July heat was on the move, dressed in its Whitsuntide best clothes which were enjoying their first airing since the previous Sunday. Inwardly fortified with Wakes ham, excited, chattering children dragged their parents towards Mecca at a somewhat brisker pace than that employed on their last visit to Sunday School—that weekly bane on youthful spirits—penance, suffered for six days of sinful living by young dogs called boys, creatures who shuffled reluctant feet towards an unattainable salvation twice on every Sunday, without let up. However, these dismal thoughts could be cast to the winds and forgotten in the din of the fair.

46

The larger amusements occupied the centre of the ground and so were fairly close together in which case each organ strove to out-do the other. There were the Dragons and next the Cranky Horses. People passing between the two would be regaled on the one side with perhaps "She's a Lassie from Lancashire," and should perchance an amorous youth allow his eager eyes to linger on a pretty girl and in return she look at him askance, then should the organ on the other side be engaged in a spirited rendering of "She was one of the early birds" it would take little else to convince him that he was still "one of the worms." Thus rejected, his natural hunting instinct would prompt him to seek other quarry.

For the very young children, much smaller versions of horses, on to which they could be strapped, were hand operated, and small swing boats were very popular, made more exciting by the accompaniment of the organ music. The organs were splendid affairs fronted by pipes similar to a church organ, and mounted before the pipes were three Dresden-like figures dressed in Regency-style gaily coloured frock coats and cocked hats.

The figures were mechanically animated, the centre one representing the conductor wielding his baton in a rheumatic kind of way supported on his left by a stern-looking kettle drummer whose facial expression seemed to imply that he at least was keeping time with his stiff little sticks. The trio was completed by a happy-looking marionette performing wonders on the triangle, the whole ensemble stridently proclaiming that "William Tell" was in town, but the tune issuing from the adjacent organ suggested that this fabled archer was not in pursuit of the boy with the apple, but intended his arrow for the apple of the eye "The bird in the gilded cage."

Girls were sliding down the Helter Skelter vainly trying to hold down their skirts, all blushes and giggles, watched by a bunch of youths (shrewd judges of legs), stationed near the landing mat (where skirts went even higher) making a mental note of the best pair of pins. This entrancing sight caused them to follow the legs to the Cakewalk which jostled and bunched everyone together, where this proximity enabled one to feign a stumble and grab the girl in front and discover the quality of her upholstery. After all this bumping and sweating the girls would seek a cooler clime, and on approaching the fortune teller's tent, the one who believed in miracles delved into her purse for sixpence, then entered this sanctum of secrecy with high hopes.

She emerged inside two minutes, with highly coloured cheeks and excitedly informed her friend she was soon to meet a dark stranger—a man. "Yes," said her friend, "there he is." Yes indeed, there he was, a

dark man with a black beard and bleary eyes who had imbibed too well in the Market Hotel. His glassy stare shook our believer's confidence— "Never mind", said the friend, "for though we can see but one of him, he can see four of us and while he makes his mind up which to choose, we'll make our getaway," on which she grabbed the hand of rosy cheeks and hurried off to the less complicated world of the 'Dodgems.'

For tuppence one could view the fat lady, a prodigious creature reputed to weigh forty stones. Her piggy eyes peered above rotund cheeks that fell into folds beneath her chin, this multiplicity supported by an ample bosom, generous enough to lay a dozen weary heads upon to soothe their cares away. One wondered how they got her to bed at night—maybe she was winched from the tent into a pantechnicon van and the process repeated in reverse the next morning?

Nearby was the tatooed lady, a multi-coloured Amazon who displayed her pictures to a gaping world and fire eaters demonstrated that it was possible to thrive on a diet of paraffin and matches.

Everywhere could be heard the cry "Touch'em on the top to win," issuing from the coconut shies where young bloods showed off their skill and wooed the girls with a nut in the hope that its sweet substance possessed amorous qualities.

Sutton Junction Station and Adlington's Mill.

48

Amongst other attractions were Hoop-la stalls, rifle ranges and various other small features common to most fairs, but one deserves special mention because of the general amusement it caused. I think it was called 'Tip the Lady.'

This sensational creature demurely reclined on a bed suspended over a dais with steps leading down to the main platform. In the interests of the lady's comfort each step was strewn with cushions and at the bottom of the steps lay a further heap to welcome her in the gentle fashion due to every lady. She lay on her lofty bed with a disdainful expression, for all the world looking like a harem beauty awaiting the pleasure of her lord. Her boredom was such as to suggest she was rather tired of being used as a rolling pin for the entertainment of the public at large.

The bed was supported on hinges in such a way that when the bullseye of a target was hit by a wooden ball it operated a retaining mechanism, which when released, caused the bed to tipple sideways and launch her ladyship on her perilous journey. There was never any lack of either spectators or marksmen so the boys lined up for the fray (four balls for sixpence). Each time the bullseye was hit, out came the lady, all flaying legs, petticoats and flounced drawers, bumping down the steps bereft of all dignity to the accompanying screams of virtuous ladies and the titillation of every male eye. In those straight-laced days, such daring exposure of forbidden regions would set all spinster tongues awagging and cause every parson in town to pray for guidance for all bachelorhood and the welfare of all maidens, but still choosing to ignore the common sight of drawers and bloomers billowing in the wind like twin balloons on every Monday washline, considering them to be sacrosanct as they contained nothing more wicked than fresh air and were newly-washed— they therefore warranted no second look, though they did betray some unflattering waistlines.

Perhaps the greatest attraction amongst the side shows was the boxing booth.

On a platform in front of the tent the promoter exhibited his fighters, men of varying weights all stripped to the waist, looking fit and ready for battle. These tough young men travelled the fair circuit and treated their bouts as training sessions in the hope that later they could turn fully professional. Some did become champions, so any challenger needed a bit of fighting skill—it was not just a game. On the other hand some of the local boys belonged to a boxing club just because they loved a scrap and others (if they had a few pints of beer), were filled with Dutch courage. The attraction was the ten bob they would get for every round they could weather.

49

Strictly speaking it was not a case of winning or losing but a plain matter of survival and if they could do that for five rounds, well, fifty bob represented a week's wages, earned in the space of minutes. There were always challengers, so when the bouts were fixed up the contestants went into the tent to be gloved up and the crowd queued to pay and filled the tent to suffocation.

The bouts were properly controlled and nobody suffered more damage than a red nose and a thick ear. I have seen quite a few such exhibitions, all good clean fun and entertainment, though if the local boy kept getting up for the next round, the longer he went on the harder he got thumped. Nobody was really hurt and there was always a full house.

All pleasures of the flesh if pursued too ardently and too long, inevitably lead to a premature grave, so such a rich diet of fat ladies, bloomers and bruisers (not forgetting the sensational descents on the Helter-Skelter and the delights of the Catwalk), had sometime to be brought to an end, if only to avoid the total decimation of junketing Suttonians.

The Wakes duly ended on Tuesday midnight when organs wheezed to silence, roundabouts groaned to a halt, soothsayers packed away their crystal ball and pugilistic young men went home to treat their 'shiners' with raw beefsteak.

The next day we watched the dismantling of the amusements—again to the last bolt, and with sinking hearts bid them farewell with the agonising thought that we had a hundred and four Sunday School appearances to make (twice on a Sunday), before we saw them again. The ham was reduced almost to the bone by this time but had its final fling in the stewpot with the addition of dried peas, (popularly referred to as "musical fruit"), and then there was nothing of it left but the bare bone which in due course would be collected by the rag-and-bone man.

Thus we began with a ham and finished with a ham, and all Mums and Dads prepared to bend their nose to the grindstone that would surely be set in motion the very next Monday.

Cricket

Cricket was the most popular summer game. There was no great problem in providing the necessary tools. A piece of board was easily fashioned to the shape of a bat, with the aid of Dad's saw. It may not have been a joiner's job to look at; but it served its purpose. Balls were no greater problem as we always had some at hand made of wood salvaged from last year's wakes.

The wicket would be a pile of bricks or somebody's jacket hung on a stick driven into the ground. The pitch would have contours nearer to those of a golf course than those of a billiard table, with the consequence that one never knew whether the ball would connect with the bat, or thump you on the nose.

As we had no such luxury as an umpire, this often led to a number of arguments as to whether a man was out or not. The batsman always maintained he was not out. Had there been an umpire, bold enough to give an out decision, his skull would have certainly have been in danger from the bat of the indignant budding test player.

The absence of an umpire must have averted many a tragedy. It is obvious from the foregoing that it was very difficult to dislodge some batsmen, but a sure fire remedy was to send him a vicious bumper, and knock him out, in which case he needed no further persuasion and the game could then continue. The game being a mixture of sport and debate enabled some to draw on their stock of adjectives and others to improve their swear words.

Some years later, when I was about 16, a group of enterprising young men formed a cricket club at the Church which my friends and I attended.

Farmer Mr. Fred Walton, of Prospect Place, Sutton allowed us to use his field at the bottom of Silk Street, when we were all enlisted—his son included—which speaks volumes when considering the loan of the ground. We borrowed a spade, a mower and a roller, then set about transforming a pock-marked, lava-encrusted surface, which resembled the top of a volcano, into a second Trent Bridge; but later mishaps and bruises confirmed that to be a vain hope. I should add there were cows in the field.

If one aspires to perform on the cricket stage, and cannot quite play the part, one must certainly look it. So we decked ourselves out with white shirts, flannels and boots. Fixtures were arranged, and we paid our secretary a bob a week to cover equipment replacements, having already paid a membership fee for its initial purchase. There were only three of us

boys in the team—the rest were young men—and our pocket money was strained to the extent that we had to forego our secret smokes and occasional ice creams. We won a few matches and lost a lot. Win or lose, it didn't matter much, it was great fun, a happy release from the hum-drum of a week's work.

Of all the matches I took part in with that Club. I remember only two. One a home match in which by some miracle, I managed to score 23 runs and was patted on the back by one of my pals, saying: "We'll make a batter of him yet." Sadly I failed to live up to my newly-won reputation by relapsing into a monotonous procession of ducks and twos.

The other match, played away, was a 'test match' a test of cowardice, courage, heroism and physical endurance, not to mention foolhardiness. No one but those with suicidal tendencies would endanger their life on such a pitch.

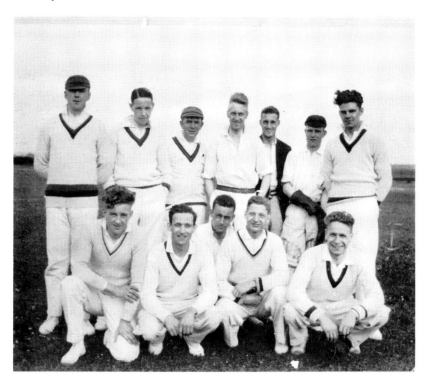

Work's Second Team, 1930. Back, L to R: Hedley Bestwick, A.N. Other, Sam Ben, Ken Dodson, Syd Buxton, Brian Keeton, Arnold Gill.
Front: Horace Smith, Ben Denby, Cyril Turner, Walter Garner, Charles Sanderson.

Our opponents were a chapel team, 'strict and particular Baptists' who, though they might have earned immunity from the vagaries of an unpredictable cricket ball by virtue of their strict faith, they were certainly not particular about the state of their wicket.

I remember few details of that particular contest, but can say that a demon bowler was responsible for our undoing. They must have batted first, as otherwise a posse of ambulances would have been engaged in carting us away, one by one as we fell, and the match declared null and void. At this point I wish to stress that all our matches were friendly matches.

The ground, apart from the usual hazards of such humble arenas, had a most unusual feature for a cricket ground, inasmuch that from one end of the pitch the ground sloped away after a matter of 12 paces, then hurriedly descended to a retaining hedge some six feet below. The hedge bottom was the habitat of a forest of cow parsley, thistles and stinging nettles, and was responsible for a number of 'lost balls,' the retrieval of which was accomplished at the cost of a rash of scratches and blisters.

Eventually the home team was dismissed and we all retired to that corner of the field which served as a pavilion, they to gird their loins and we to apply dock leaves to our punctured skins. After the interval the home team took the field and our two opening batsmen walked briskly to their crease, number one taking his guard and turning on his heel in the most professional manner to note the field placings. He needn't have bothered, he was soon to be on his way back.

The enemy attack was opened by a medium pacer from the flat end supported in turn by a slow spinner at the dip end, for whom there was sufficient flat run for his type of bowling. These two held no physical terrors for Sutton stalwarts. and there was a trickle of runs until number one, attempting to knock a 'donkey drop' for six, missed, spun round and fell on his wicket.

The breach was filled by number three and runs steadily compiled until 20 went up on the score board. This was not to the liking of the opposing captain, so he decided to reveal his secret weapon. He beckoned to a big, swarthy fellow (we were afterwards told he was the local blacksmith, and his chief delight was knocking sparks off red hot bars of iron).

He took the ball at the dip end, and to take his run up, proceded down the slope, then disappeared out of sight. After what seemed a long time the umpire called "Play," and to the sound of thumping feet the

blacksmith appeared on the horizon to unleash a thunderbolt which struck the batsmen on the knee, causing him to retire hurt.

This was the beginning of the end. Every other over the slaughter went on. Far too soon I thought, it was my turn to face the barrage. I tried to put on a brave face, and took my stance to meet impending doom. By amazing luck, and sheer fluke, I managed to put the bat in the way of the first ball and edge it straight to the boundary. Amid cheers from my team-mates—who no doubt recalled that I was the boy wonder who in a distant past had scored 23—I was urged to "have another go." That four was to prove to be the most regrettable thing that had ever happened in my young life.

With a murderous scowl the bridling blacksmith stalked down the hill to repeat his disappearing trick. He was so long in preparation for the ultimate, that I thought, and hoped that he had gone home, or got lost in the cow parsley. My hope was the playmate of delusion, for ere long a bobbing head broke the horizon, followed by a massive torso that galloped along like a cavalry officer's charger bent on my destruction. A mighty arm that daily fashioned horse shoes, released a meteorite that struck a bump, then reared and chose my forehead for a target, setting off a peal of bells in my poor head.

Since I still stood up, a harmless object was tossed back to the bowler, who departed once more to the parsley patch. After the customary interval he re-appeared but as my sight was somewhat impaired by the sweat trickling into my eyes, I never saw what was hurled at me, but on turning round after its passage, saw the gap where my middle stump should be.

I then followed a bemused trail back to the 'pavilion' with a relief to match that of those who survived the siege of Paris. What weight I had lost through perspiration was more than counter-balanced by the tomato on my forehead which had grown with such rapidity as to rival the prominence of my nose.

The match quickly drew to its inevitable conclusion and a band of dejected cricketers set off for home and safety, with the fervent prayer that every spreading chestnut in the land should be caused to fall on every village smithy, during working hours.

About five years after the 'test match,' I moved to Messrs. H. & B., of Unwin Road, Sutton (now Pretty Polly). It was a very small firm in those days, but they did have a very respectable cricket field opposite the works. I joined the cricket club and thus had access to better wickets.

On rare occasions—when it was necessary to scrape the bottom of the barrel—I appeared in the tail of First 11, but my true home was with the second squad. The First team included one of the management and some members of the staff who took their cricket seriously. This, for us of lower degree, was too much like being at work, and I much preferred the relaxed atmosphere of the second string, all but one of whom were bachelors unbowed with care. However, for a match against Ollerton village I was again fished out of the barrel to travel with the elite, mostly men in wedlock. My main purpose in writing about that day, is to illustrate that there is a social side to cricket if you care to look for it. Though I loved to play the game for its own sake, that other side held a strong appeal for me.

After a home game I hurried home, got my best trousers out of the trouser press and enthusiastically rushed off to do my courting. My girl (whom I was later to marry), was a very sensible and tolerant young lady, who didn't insist on having a youth forever hanging round her neck. So on the Ollerton occasion, knowing that we would very likely be late she didn't expect me home to pay my court. This, as will later be seen, gave me the chance to let my hair down, meanwhile trusting she would do nothing worse than shampoo her own in my absence.

The ground was that triangle wedged between the Mansfield and Worksop roads at what is now Ollerton roundabout, and formed the tip of Sherwood Forest at that point, an ideal setting for a village cricket match. It was a lazy Saturday afternoon in high summer, when the drone of bees lull the senses of a townsman to rustic tranquility, and the only disturbing note might be a passing car or the cry of the ice cream man, a day when any dreaming romantic in white flannels, in search of a ball he had allowed to go among the trees, could well imagine the Sheriff of Nottingham combing the undergrowth when in pursuit of Robin Hood or Friar Tuck.

The details of the game are not important, but I remember we finished play well on in the evening. There was then a general rush by the 10/11ths of our team for Mansfield-bound buses, men anxious to fulfil their marital duties.

This left me—and a friend who had gone along with me for the day—as sole representatives of Sutton, left in Ollerton. After such a hot and thirsty day, we decided to seek the 'Plough' in the village, not to turn the sod, but to turn a few beer mugs bottom to top, a pastime of young dogs not on a lead. Part of their quest for knowledge, for who can tell the tares without first sowing the oats?

55

After a cheese sandwich from the bar, we settled down to replace some of the moisture lost during the afternoon. It was a merry company, easily moved to song and as the evening wore on we were urged to 'pack up our troubles in the old kit bag' and also treated to several renderings of 'Nellie Dean,' until someone struck up with 'three o'clock in the morning,' which reminded us there was such a thing as time.

We discovered the last bus was gone and there were no taxis. There was nothing for it but to walk home, if we were unlucky enough not to get a lift by a late motorist. This I think we may have done, but honestly I have absolutely no recollection of how we got to Sutton. What I do very clearly remember is the pair of us leaning on the stone wall that enclosed the Lammas, this again quite inexplicable because our direct route home shouldn't have taken us there.

I further recall my realisation that my dear girl lay in her bed not a stone's throw away, and with a silly grin fervently hoping I was flitting through her dreams with a golden bat, slashing sixes with the gayest of abandon. I do not remember saying goodnight to my friend but I do remember scrambling through the kitchen window at home, always left unlatched for latecomers.

This had been my longest cricket match ever, for the clock on the wall read 3 a.m. Sunday morning. With a chuckle I realised I had been 'playing cricket' for 14 hours and had not even got home on the same day. Being a believer in the great wisdom of our forefathers I did agree that discretion was indeed the better part of valour, so I mounted the stairs resolved to keep my peace regarding this little escapade.

To total abstainers and Wesleyan consciences, we uninhibited cavalier cricketers may have been regarded as being well on the way to that ruin and damnation so frequently prophesied for us in our more tender years on every winter Tuesday evening at the Band of Hope. Any such fears were proved to be groundless for though we were not much good at cricket we managed to beat the devil and become good citizens, pay all our taxes, settle down to married life, and furthermore, vote for the parson should he be put up for the local council.

Of all the little follies committed in my youth none but those I missed cause me the least regret. Therefore I say to all anxious mothers whose sons clamber through scullery windows at 3 o'clock in the morning 'fear not, for they too will pay their taxes and vote for the parson.'

The Monkey Run

When I was a juvenile romantic, I and many of my contemporaries went to Sunday School each Sunday morning. Not that we particularly relished it, but our parents insisted on the cleansing of our souls. We sang a few hymns, got a talking-to and were then released from purgatory.

This left us with a couple of hours to take a walk and work up an appetite for dinner. After the last mouthful we were immediately on the way back to school, hiccuping and fighting the stitch, to take a second laundering. On our blessed release, the youth of the town made a bee-line for fairyland.

The Monkey Run proper began at the top of Oatses Hill (now Forest Street) and proceeded down to the Lawn gates.

At about 3 p.m. each Sunday afternoon, when the doors of the schools were flung open, a stream of boys and girls set off from Hardwick Street (St. Modwen's). Reform Street (Primitives), Victoria Street (Congs). St Mary's contingent moved down the Lammas to be joined on Portland Square by the Wesleyans, New Cross Methodists, Bown Street Chapel, Zion Baptists plus all those wretched young heathens who did not attend Sunday School.

Thoughts were not now centred on religion but on romance, so eager young feet scurried along in their Sunday footwear, (worn strictly Sundays only) to join the main stream on Station Road, their boots emitting a rhythmic squeak in tune with the clomp of many pairs of heels.

It may be interesting to note that in those days, new footwear always squeaked—why I couldn't say, but since they were issued to us at Whitsuntide for the annual walk-round and were only aired once a week, it took until August Bank Holiday for the squeak to wear off.

The wags used to say that squeaking shoes were not paid for! However, we must not tarry to consider the de-merits of leather but must catch up with the mainstream, now slowed down on account of numbers, with the accompanying squeaks assuming a more leisurely tempo. The stream is as sluggish as the River Idle—now is the time for observation.

See the boys: shoes polished up to mirror perfection, patterned socks peeping below trouser bottoms, trouser creases (the hallmark of a natty fellah) laboriously created with the aid of a flat iron, a waistcoat (commonly called a 'weskit') always with the bottom button undone (being so trussed-up it gave one a wonderful sense of freedom), a jacket fresh from the wardrobe showing not a crease, a shirt and starched collar

(these were rather hard on Adam's apples)—all this topped with a bowler hat or a pork pie trilby.

Should some young blade have the courage to ignore the contempt of his pals and wear a pair of yellow socks (this was considered to be very daring), he would hitch his pants well-up with his braces for the benefit of the world at large, and for females in particular. This could be emphasised when sitting down in public. By using your hands, trouser bottoms could be yanked up to the dizzy height of your knees. You could modestly excuse your action by saying that you were trying to keep your hard-won creases in, but the truth was that you were giving 'em all a treat. Should knees be visually indifferent there was no need for worry: the beholder's eyes would be riveted on the yellow socks.

Now what of the girls: At least one good thing came from the Kaiser's war—the dawn of the emancipation of women. It was no more evident than in ladies' fashion. During the War, many young women had worked in munitions and for practical reasons such as operating machinery, had worn overalls and also dispensed with their curls. This shortening of the hair was called 'bobbing'. After the War, the fashion stuck and 'bob' became the order of the day.

Many fond mothers shed many bitter tears when their daughters returned from the barber's with their curls in a paper bag. Hair lengths had shot up, and not to be outdone, dress and skirt hems bid the ankles goodbye and took a sensational leap to above the knees. Thus was created the first generation of boggle-eyed young men. This was not to be wondered at, as it was noted that these delectable creatures had dimples on their knees besides those on their cheeks. Yet as though half afraid of their boldness, these birds of paradise paused in their transformation.

Bosoms and bottoms disappeared overnight—how remains one of the great mysteries of womankind—why will never be known. To give some idea of the severity of this pause: if these enigmatic beings had sat upon a tea saucer there would have been saucer to spare. This strange new species were called 'Flappers'.

These were the lovely girls who sauntered their leisurely way down Station Road, hips and skirts alike swinging in perfect harmony, a kaleidoscope of rainbow colours in their summer Sunday Best. Gone were all the old, dingy navy-blues and browns. Hitherto such colours— and black—had been considered as attributes to modesty. Fie to modesty, let it be gone!

Very many of the girls worked in the hosiery factories which were at that time approaching a high production of pure silk stockings which they

58

could buy at a reduced price from their place of work. Previously silk stockings had been the prerogative of queens and duchesses, and since their legs were fit to grace a queen, the local beauties vied with the royalty.

Such glamour had to be supported by an equally glamorous ensemble. Lovely dresses in cotton prints, art silk, pure silk, high-necked, low necked, long sleeves, short sleeves, puffed sleeves—so it went on. Tailored costumes with plain or pleated skirts were very popular and indeed very smart, made up in cloths light or heavy according to season.

A few of the bolder girls sported ornamental silk garters just above the knee (they held nothing up). In the act of sitting down on a park bench or on the grass, these were displayed to full advantage. This caused an optical reaction from the boys. Their eyes popped out like chapel hat pegs.

This was rather hard on a boy who had been considering giving them a wink, as no normal eyelid could cover such extended orbs, therefore the feat remained unaccomplished.

Just imagine these temptresses, gathered in little groups, feigning nonchalance but well-knowing they set many hearts a-thumping in manly chests. But for some diversion, half the boys would have been carried back to their mothers on a bier.

This diversion, this blessed relief, appeared in the shape of the Town Band—Sutton Temperance Brass Band. The temperance bit in the title I always felt to be something of a misnomer, as at the annual walk round—if not chosen to accompany the hymn singing from the other bands present—they would sit on the steps of the Market Hotel and quaff a few pints of foaming beer, intermittently removing the foam from their lips with their unoccupied jacket sleeve.

On the Lawn they performed on a stage composed of planks supported by empty beer barrels. Had the barrels been full, they would have been under the stage, as no power on earth could have enticed them on top until they were empty.

As the conductor (Mr. Arthur Spencer) raised his baton to call the attention of his players, a hush fell on the mightly concourse and the first strains filled those bursting hearts. A stirring march was a favourite opening number and as the crashing chords reverberated through the air of the Lawn, ripples appeared on the surface of the dam and the River Idle quickened its flow.

After the show the afternoon was far advanced and tummies were beginning to roll. With invisible tea bells ringing in our ears we all made our way back up the Monkey Run to our respective homes.

After tea we all went to church for the ultimate cleansing of the day, after which the afternoon performance was repeated. We returned to work on Monday with the comforting thought that there were plenty more Sundays to come. After these many years, the very thought of those Sundays brings a nostalgic lump to my throat. That period was the bridge of adolescence which led to maturity.

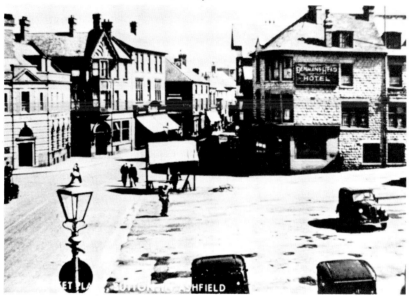

Sutton Market Place.

"Smoking"

We dared not smoke outside, so four or five of us would 'club together' to buy a packet of ten between us for 2½p. We thought that we had really accomplished something when we could blow the smoke down our noses like dragons on the rampage. Mark you, I had had a little previous practice as my younger brother and myself used to get up early before school and, after father had gone to work, we would raid his 'bacca tin' to make a cigarette rolled in newspaper.

This was a dead, dark secret, that was never discovered, but I must take responsibility for the initiative as I am sure that my brother would never have done it alone.

Courting

I went to my first dance at one of the local church halls when I was about 17, along with another boy. He led me on, for never would I have thought of it myself as I was far too shy with girls. I kept my debut dark and did not mention it at home. "Let'em find out," I thought, as I feared suspicious glances and suggestions that 'anything could happen at a barn dance,' though it would have been rather difficult to strike a parallel in this instance as there was no hay in the church hall. Be that as it may, we were not to be exposed to the wicked wiles of the female and nor were the girls to be ogled by us boys—let alone touched.

The dance was more enjoyable to me than any that were to follow, as it was a new experience to be in the company of girls socially. I soon overcame my early embarrassment as the girls were so friendly. They were quite unlike the dangerous creatures of previous warnings and were there only to enjoy this happy get-together.

I could not dance, and indeed was never very good at it, but they were sporty girls and demonstrated a few steps—enough to get along with. The old type of square dance, like D'Alberts for instance, had not yet given way to the more sedate ballroom dances of later years.

These party dances were exuberant and bustling affairs, lively and vigorous; we soon had red faces and glistening brows. Four people took part in each set, alternating from corner to corner with the same set steps of the dance as distinct from the improvisations of the later foxtrot and quickstep. Partners were exchanged during the course of the figures. On this occasion we danced with the same two girls all evening. One was a very bonny girl and I remember her ruby face shining with perspiration and happiness, completely without self-consciousness as she had yet to reach the age of sophistication. It was great fun. After this initiation we began to take a little more interest in girls but not on a frequent basis.

The boys I knocked around with had been my friends from boyhood, and we considered ourselves to be 'men's men.' Girls provided just a pleasant diversion but no more. Furthermore, we were still within range of the parental eye, and also did not wish to be 'tied down'—liberty was too precious.

On reaching the age of 21, I asked if I could pay my own board—note that I had to ask. I was in regular work and earned two pounds each week and was given five shillings (25p) from my wage packet as pocket money, by my mother. I felt that it was time to manage my own affairs and to have

a little more money to use as I pleased. I wanted independence and to break the bonds of teenage frustrations. In law, I was now a man able to make my own decisions for good or ill.

It so happened that hosiery was entering a boom, and I was soon earning quite a bit more money. Though I did not like the job any better, I did at least realise that I had to come to terms with it. Like my friends, I soon owned a motorbike and lost my shyness with girls.

When I was 22, that is, in the second year of my maturity, it came to the ears of father that I was keeping company with a girl (it wasn't the first, but he didn't know that). He drew me aside one day and warned me of the "pitfalls" (there, I quote him). I was staggered. Here was I, a grown young man—in law—my own boss; being lectured like a boy of ten. He also placed a certain onus on me which I shall not repeat.

I calmly assured him that I "knew all about it" and that plenty of my contemporaries were already married, and so left it at that. In later years, my younger brother told me that when he started courting the girl he was to marry, he too was put on the mat, and told: "You've GOT to stop it my lad," in no uncertain terms.

In the summer of 1929, I laid siege to the lady who was to became my wife. We both worked for the same firm, employed in adjoining rooms. The dividing wall was glazed and she worked against the window between us, no more than a yard or so from me. Because of the din of machines, in addition to the glass barrier, it was impossible to converse, but possible to indulge in sign language.

I am afraid that there was only one participant in the gesticulation as she merely turned up her nose in disdain. I had a few girlfriends prior to this, though nothing serious as my thoughts could not have been further from marriage. I had a wonderful freedom and intended to keep it for some time to come. This girl was very different from the others. She had straight black hair, fine even features, lovely colouring in her cheeks and a proud, imperious expression. I was more than usually attracted by the first sight of her. So I began my assault on this young lady through a sheet of glass. Any spare moment, I would steal a look and give her one of my best smiles or tap on the window to draw her attention. She was not impressed with either my smiles or my physical contortions. As we worked different hours, we never arrived at, or left work, at the same times, so I never saw her except through the glass pane unless on the rare occasions around the factory. I met her in a corridor one day and politely asked if I might take her out. "Never," she replied, "Never."

Easy conquests are hollow victories; it is only when we have to fight that the prize is worth taking. I ran into her at work a second time and again made the same request, getting in answer the same icy "Never," followed by "I've heard about you."

Thus it seemed that I had acquired some doubtful honours. My failure and rejection made me all the more ardent, so I resorted to subterfuge. I was determined to meet her on equal terms if at all possible, and try to dispel any adverse impressions she had of me.

She lived very close to a girl cousin of mine who was also a mutual friend, so I enlisted the help of this cousin. I wanted her to persuade the object of my admiration to make up a foursome for a visit to the pictures. She consented to this. I briefed my own pal as to his behaviour for the occasion. He was to be at his Sunday best with manners to match, for I told him I really wanted this girl. Like a good pal, he obliged.

After the cinema and a walk home, I asked her if I could see her again. This time she said "Yes," and it went on from there. I was to discover that apart from her physical attractions (she was in her 18th year), she had modesty, dignity, immense pride, intelligence and compassion. She was broad-minded and full of character. We found that we had a great deal in common and I fell like a ton of bricks. The bachelor gay was tamed and down to earth I came.

At this time I played cricket, usually on Saturday afternoon or evening, and she never discouraged this activity, nor raised objections to my seeing old friends from time to time. She was a very tolerant girl with no meanness in her nature. We did not overdo our time together and so never had 'tiffs.' I occasionally reminded her of the "Never, never" response to my early pursuit, but we both just laughed. We haunted the countryside on the motorbike, doing thousands of miles together, singing the popular songs of the day as we went along.

One Sunday afternoon we approached a crossroads controlled by a policeman on point duty (there were no traffic lights at that time). He pulled me up to let the cross traffic go, then signalled me on. I had no sooner got moving than he pulled me up again. "Hey," he said, with a broad smile, "you've lost your girl!" I looked round and there she was on the spot where we had stopped, standing on her left foot, just bringing her right foot to rest from a horizontal position. She explained afterwards that she had got off the bike to adjust her dress, and just as she was in the act of remounting, I shot off leaving her with her legs at right angles. In later years, she sometimes referred to the time that I left her standing on one leg.

63

After nearly four years of courtship we married and set up home together. To our bitter disappointment we lost our first baby at birth, but a couple of years later we were rewarded with a daughter. Now we had what we wanted. Things were going fine for us, our ship was secure and we sailed a lovely sea. The year was now 1938.

The old Mill Dam.

Nutting

When November came, we went in droves to the woods to collect chestnuts, grown-ups and children alike, returning with pillowslips full. Pillowslips were more suitable than bags as they settled nicely on the shoulders and made it easier for children to carry them for the overall distance of six miles.

CHARLES WHITEN SANDERSON was born on 23 December 1906, in Cursham Street, Sutton, and lived in the town for exactly fifty years.

He attended Hardwick Street School, and the Upper Standard School in Station Road. He left school at the age of thirteen to start work with H. & G. Cooke, hosiery manufacturers, in Reform Street, as a knitter, at 7s 6d (37p) a week.

In 1925 he moved to Scott & Slack, Station Road, and from there to Hibbert & Buckland (now Pretty Polly) before joining the RAF in 1942.

After the War he had his own business as a seed merchant in Leeming Street, Mansfield, for twelve years. He then returned to the hosiery industry with Goldie, Wade & Goldie, Bath Lane, Mansfield, until he retired at sixty-three, due to ill-health.

Now a widower, Mr. Sanderson lives at Pleasley. In 1980 he contributed a series of articles about his early days to CHAD — Sutton and Kirkby News. These proved so interesting that he wrote another series in 1984, and a third in 1985. This book is a selection from the first and second series. The Publishers are very grateful for the helpful co-operation of the Editors of Chad in its preparation.

Mr. Sanderson has two married daughters and a son, six grandchildren and one great grandchild. When not engaged in writing, he enjoys drawing and painting and playing the piano. He reads widely, especially the classics.

OTHER SCARTHIN BOOKS

HISTORY

Hanged for a Sheep: Crime in Bygone Derbyshire. E. G. Power 1981. Second edition 1982. 80pp. ISBN 0 907758 002 £1.95. Photographs and facsimile documents. A factual but entertaining survey of crime, law enforcement and punishment c. 1700 — 1850.

Ancient Wells and Springs of Derbyshire. Peter J. Naylor. 1983. 80pp. ISBN 0 907758 010 £1.95. Photographs and diagrams. The only book on the natural waters of Derbyshire; with gazetteer of sites.

Driving the Clay Cross Tunnel: Navvies on the Derby — Leeds Railway. Cliff Williams. 1984. 88pp. ISBN 0 907758 07X. £2.85. Fully illustrated. The hazardous work and rumbustious lives of Victorian navvies.

The Story of Holbrook. Doris Howe. 1984. 90pp. ISBN 907758 053. £3.60. Illustrated. A model village history; the fruits of many years of research.

The Coal Mines of Buxton. Alan Roberts and John Leach. 1985. ISBN 0 907758 10X. £3.75. An absorbing study of the forgotten pits and pit-men of the Buxton area. Photographs, maps and diagrams.

St. John's Chapel, Belper: The Life of a Church and a Community. E. G. Power. 1985. ISBN 0 907758 118. £1.95. A sketch of the historic "Foresters' Chapel" and the people it served, by the author of Hanged for a Sheep.

RECOLLECTION

The Crich Tales: Unexpurgated Echoes from a Derbyshire Village. Geoffrey Dawes. 1983. 96pp. ISBN 0 907758 061. £2.85. Original illustrations by Geoff Taylor. Tales of earthy humour and rural shrewdness, heard in a village pub of grandfather's days.

Our Village: Alison Uttley's Cromford. Alison Uttley. 1984. 72pp. ISBN 0 907758 088. £2.85. A selection of her essays, vividly recalling the village scenes of her childhood. Illustrated by C. F. Tunnicliffe.

First Loves: Life stories of Victorian Dolls. Lilian McCrea. 1985. ISBN 0 907758 126. £5.95. Poignant stories of more-than-playthings, set in the often repressive and uncertain world of Victorian family life. Retold by Lilian McCrea, and illustrated by colour portraits of the dolls themselves.

FOR CHILDREN ...

Journey from Darkness: Gordon Ottewell. 1982. 96pp. ISBN 0 907758 029. £1.95 Original illustrations by Geoff Taylor. An adventure story for older children set in Victorian Derbyshire and centred round a pit-boy's journey with his lame pony.

Derbyshire for Children. M. S. Dodds. 1983. 48pp. Quarto. ISBN 0 907758 045. £1.20. Published for the Derwent Valley Lions Club. A book of puzzles, games and other activities, reproduced in the deviser's own stylish calligraphy.

... AND THEIR PARENTS

The Peak District Quiz Book. Barbara Hall. 1983. 52pp. ISBN 0 907758 037. £1.50. Twenty-four sections plus photo quiz, by the compiler of the successful Sheffield Quiz Books.

Family Walks in the White Peak: Norman Taylor. 1985. 78pp. ISBN 0 907758 096. £1.95. Photographs and line drawings. Devised with children in mind, but hailed in The Great Outdoors walkers' magazine as "quite simply, the best Peak District short walks guide yet published."

FORTHCOMING

Country of Stone Walls. Helen Perkins. ISBN 0 907758 134. D. H. Lawrence's associations with the Peak District and the influence it had on his life and works. Gazetteer of sites, maps and photographs.

INVITATION TO AUTHORS

The publishers, D. J. Mitchell and E. G. Power welcome ideas or MSS from new and established authors, especially where the appeal of the work is not narrowly confined to Derbyshire. Village histories and similar books of limited appeal may be considered for joint publication with authors.